START DRAWING WITH PENCILS, PENS AND PASTELS

START DRAWING WITH PENCILS, PENS AND PASTELS

practical techniques and 25 projects for beginners

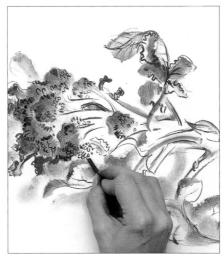

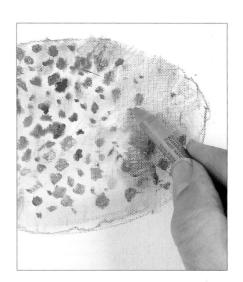

All the basics shown step by step: drawing outlines, shading and tonal work, line and wash, sketching, blending, perspective and composition – illustrated with over 300 colour photographs

IAN SIDAWAY AND SARAH HOGGETT

This edition is published by Southwater, an imprint of Anness Publishing Ltd, Hermes House, 88–89 Blackfriars Road, London SE1 8HA tel. 020 7401 2077; fax 020 7633 9499

www.southwaterbooks.com; www.annesspublishing.com

If you like the images in this book and would like to investigate using them for publishing, promotions or advertising, please visit our website www.practicalpictures.com for more information.

Ethical Trading Policy

Because of our ongoing ecological investment programme, you, as our customer, can have the pleasure and reassurance of knowing that a tree is being cultivated on your behalf to naturally replace the materials used to make the book you are holding.

For further information about this scheme, go to www.annesspublishing.com/trees

© Anness Publishing Ltd 2007

UK agent: The Manning Partnership Ltd tel. 01225 478444; fax 01225 478440; sales@manning-partnership.co.uk

UK distributor: Grantham Book Services Ltd tel. 01476 541080; fax 01476 541061; orders@gbs.tbs-ltd.co.uk

North American agent/distributor: National Book Network tel. 301 459 3366; fax 301 429 5746; www.nbnbooks.com

Australian agent/distributor: Pan Macmillan Australia tel. 1300 135 113; fax 1300 135 103; customer.service@macmillan.com.au

New Zealand agent/distributor: David Bateman Ltd tel. (09) 415 7664; fax (09) 415 8892

All rights reserved. No part of this publication may be reproduced, stored in a retrieval system, or transmitted in any way or by any means, electronic, mechanical, photocopying, recording or otherwise, without the prior written permission of the copyright holder.

A CIP catalogue record for this book is available from the British Library.

Publisher: Joanna Lorenz Editorial Director: Helen Sudell Editors: James Harrison, Sarah Hoggett and Elizabeth Woodland

Photographer: George Taylor Designer: Nigel Partridge

Cover designer: Nigel Partridge

Project contributors: Diana Constance; Abigail Edgar;

Suzy Herbert;

Wendy Jelbert; Melvyn Petterson; Paul Robinson; Ian Sidaway; Effie Waverlin

Editorial Reader: Rosie Fairhead Production Controller: Wendy Lawson

Previously published as part of a larger volume, The Practical Encyclopedia of Drawing

Contents

Introduction	6
Monochrome media	8
Coloured drawing media	10
Pastels	12
Pen and ink	14
Supports	16
Additional equipment	18
Making marks	20

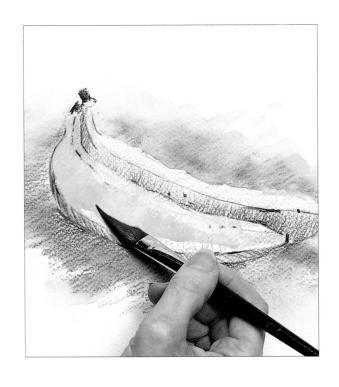

Blending with water-soluble

penciis	64
Brush drawing	66
Line and wash	70
Masking	74
Eraser drawing	78
Sgraffito	81
Drawing smooth textures	84

Drawing rough textures

Drawing soft textures

Line drawing 22

shapes 24

Seeing things as simple

Understanding tone	30
9	

Adding tone	32
-------------	----

Measuring systems	38
-------------------	----

Negative	shapes	40
Negative	Silapes	70

Perspective	44
Perspective	Z

Blending with coloured

pencils	54

Blending with soft pastels

and oil	pastels	58

Index

96

88

92

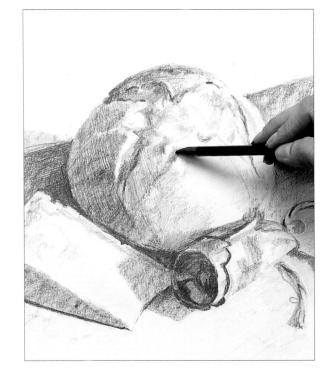

Introduction

Drawing is often regarded as a special gift, and it is true that there are people who seem to be able to draw quite effortlessly. Yet drawing, like writing, is a skill which can be acquired; if the motivation is there, most people can learn to draw accurately.

You don't need a lot of equipment to get started, but it's a good idea to experiment by making marks with different media to see what suits you, whether you naturally prefer the smudgy line and soft tone of charcoal, the delicacy of pencils or the precision of pen and ink. You may also want to explore more challenging media and techniques, such as brush drawing and working with masks, or introduce colour into your work using water-soluble pencils and washes.

There is now a wider choice of drawing materials than ever before. In fact a selection of pencils – a 2H, HB, 2B, 4B and 6B should be

Woodland scene ▼

For this energetic drawing, the artist has used oil pastel, an ideal medium for bold effects and quick impressions. See how the use of a light colour draws your eye into the distance.

adequate for most purposes – charcoal, coloured pencils, pastels, inks and a pad of paper are more than enough for most people's needs to begin with. Once you have bought your basic equipment, the next step is to become familiar with the materials and learn how they behave when you use them. As you practise and develop your own style, you will build up a collection of equipment as you go along.

In this book there are 25 practice exercises show how to analyse complex objects as a series of basic shapes, seeing the 'bones', or underlying structure of your subject, whether it is a tree, a building or a person, and there are informative sections on technical skills such as reproducing tone and understanding perspective, which will help you to give your work solidity and depth.

All the popular subjects are covered: still lifes, landscapes and buildings, trees and flowers, with each designed to be easy to follow, and there are detailed colour photographs illustrating each step so you know exactly what your are doing.

Do not worry if your first attempts do not look exactly like the ones reproduced here. The most

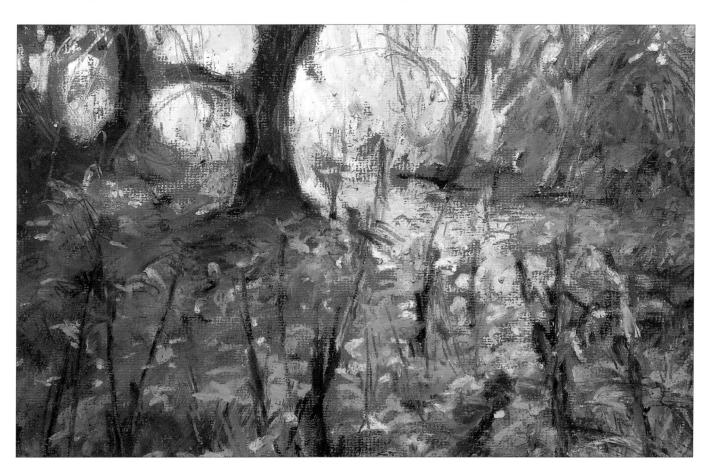

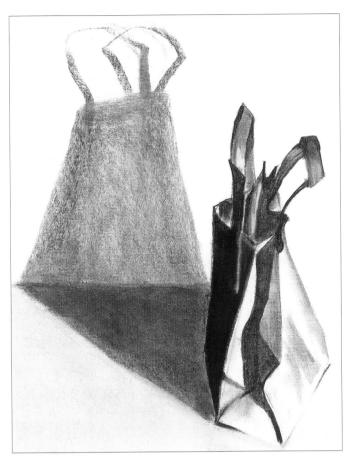

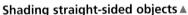

Here the artist has used a thin charcoal on a plain white background to create a wonderful sense of shape and form.

scary thing for every artist is simply getting over initial inhibitions about making the first marks on a blank sheet of paper. Set aside a little time for drawing each day, if you can – and after a couple of weeks, look back and assess your progress. You will be amazed at how far you have come.

Try to make time the time to practise these projects – do as little or as much as you want each session. You can either copy the projects step by step, exactly as shown here, or use them as a starting point for your own artistic explorations. All the projects are packed with useful tips and general principles that you can apply to subjects of your own choosing – so take the time to study them carefully, even if you do not reproduce them all.

As your drawing skills progress you may find that you want to adopt a more painterly approach. Pastel is a unique medium, in that although it has all the directness and spontaneity of drawing, the blending and layering of colours

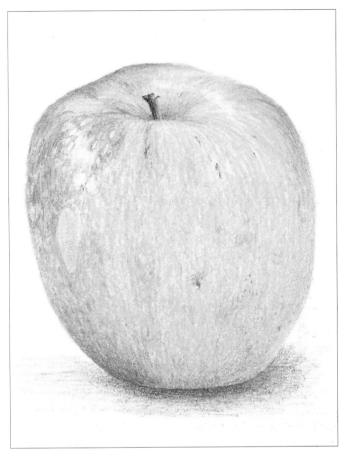

Blending with coloured pencils A

Coloured pencils are the perfect medium for creating a beautifully detailed and textured surface.

are more closely related to painting. Pastel colours can be delicately blended to create misty, atmospheric effects, or jabbed into coarsely textured paper in thick layers of blunt strokes, resulting in pictures of great drama and depth.

All the artists featured in this book have built up a wealth of experience over many years of study, which they share here with you in the hope that you will gain as much pleasure and enjoyment from drawing with pen and ink, pencils and pastels as they have experienced. With time and a bit of practice, you will soon be creating works of art that you can be proud of.

So if you thought you had no talent for drawing, let this book change your mind. In a series of inspiring step-by-step demonstrations, it will show you how to look at the world with an artist's eye, and how to break down seemingly complex subjects into simple shapes, drawing what you are really seeing instead of what you think you already know about an object.

Monochrome media

The most commonly used drawing implement is the so-called 'lead' pencil, which is actually made not from lead but from a form of soft carbon known as graphite. The purest seams of graphite were discovered by chance in Borrowdale in Cumberland (northern England) in around 1500: after a heavy storm, local shepherds discovered that trees had been blown down, exposing large masses of an unknown black material. At first they thought it was coal, but it didn't burn; they then realized how good it was for making marks, and used it to mark their sheep. It was not long before people realized the potential of graphite as a drawing tool and it quickly spread across Europe, replacing the traditional silverpoint. To make a graphite pencil, graphite is reduced to a powder, which is then mixed with clay to make a paste; the paste is then extruded as a thin strip and encased in a wooden barrel made from a smooth-grain cedar.

The barrel of a graphite pencil may be round, hexagonal or triangular in shape. The choice of barrel shape is a personal one but, as a general rule, round barrels are easy to turn between the fingers while hexagonal and triangular ones are more stable to hold.

Pencils vary in hardness. Each grade is given a code that runs from 9H (the hardest) down to HB and F (for fine) and then up to 9B, which is the softest. The degree of hardness is determined by the relative proportions of graphite and clay: the more clay in the mix, the harder the grade. A selection of five different grades — say, a 2H, HB, 2B, 4B and 6B — should be adequate for most purposes.

Each grade of pencil is capable of making a mark of a certain density. Soft pencils give a very dense, black mark, while hard pencils give a grey, rather than a black, mark. If you require a darker mark, do not try to apply more pressure to the pencil, but switch to a softer grade.

Grades of pencil ▼

To make these marks, the same amount of pressure was applied to each pencil. You can clearly see how different grades of pencil produce marks of different density.

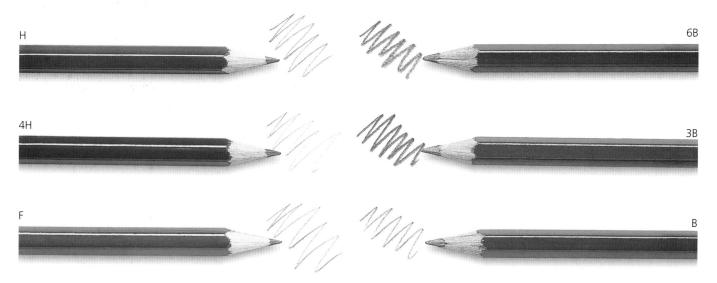

Water-soluble graphite pencils

There are also water-soluble graphite pencils, which are made with a binder that dissolves in water. Available in a range of grades, they can be used dry or worked into with a brush and water to create a range of watercolour-like effects.

Water-soluble graphite pencils are an ideal tool for sketching on location, as they offer you the versatility of combining linear marks with tonal washes. Use the tip to create fine details and the side of the pencil to cover large areas quickly.

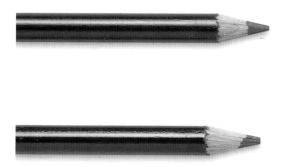

Tips: When you are sharpening a pencil in a pencil sharpener, the shaving should come out as a long, continuous strip. If it does not, then the sharpener is blunt and should be thrown away.

You can also sharpen pencils using a craft (utility) knife. Hold the knife at a very shallow angle and stroke the blade lightly along the wood of the pencil tip. (If you dig in too deeply, the graphite strip will almost certainly break.) Replace the knife blade regularly so that the blade is always sharp.

Graphite sticks

Solid sticks of graphite are available in various sizes and grades. Some resemble conventional pencils with a round profile, while others are shorter, thicker, and hexagonal in shape. Thick, short round sticks can also be found, as can sticks with a square or rectangular profile. You can also buy irregular-shaped chunks and fine graphite powder.

Thinner strips of graphite in varying degrees of hardness are also manufactured to fit in a barrel that has a clutch mechanism. These often have a sharpener hidden in the device that is pressed to operate the clutch.

Because of their shape, graphite sticks are capable of making a wider range of marks than conventional graphite pencils. For example, you can use the point or the side of a square- or rectangular-profile stick to make a thin mark, or stroke the whole side of the stick over the paper to make a broader mark.

Square-profile graphite stick ▼

Like graphite pencils, graphite sticks come in a range of grades, with a softer grade making a denser, blacker mark than a hard grade.

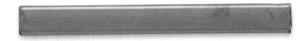

Charcoal

The other monochromatic drawing material popular with artists is charcoal. Charcoal is usually made from willow, although both vine and beech charcoal can also be found. It is made by charring the twigs at a very high temperature in airtight kilns.

Charcoal comes in different lengths and in thin, medium, thick and extra-thick sticks. You can also buy large, irregular-shaped chunks that are ideal for very large, expressive drawings. Stick charcoal is very brittle and breaks easily if you press hard. It is very powdery and is wonderful for creating broad areas of tone.

Compressed charcoal is made from charcoal dust mixed with a binder and fine clay and pressed into shape. It is harder than conventional charcoal and does not break so easily. It is also less messy to use. Rectangular or round compressed charcoal sticks are made in varying degrees of hardness.

Compressed charcoal is also made into pencils that either have a wooden barrel that is sharpened in the same way as a traditional graphite pencil or are set in a paper barrel that is torn away as the charcoal strip wears down. Because the charcoal is covered, charcoal pencils are much cleaner to handle than stick charcoal. They also have a slightly harder texture. Unlike stick charcoal, charcoal pencils are ideal for detailed, linear work. However, only the point can be used, so if you want to block in large areas of the paper quickly, it is perhaps preferable to use the side of a charcoal stick.

Charcoal smudges extremely easily, so you should wipe your fingers regularly when drawing with it so that you don't leave fingerprints on the paper. As with other powdery mediums, such as chalk and soft pastels, drawings made in charcoal should be sprayed with fixative to hold the pigment in place and prevent smudging. Fixative is readily available from art and craft stores, but hairspray makes a good and inexpensive alternative.

Various forms of charcoal ▼

From top to bottom: thick charcoal stick; thin charcoal stick; compressed charcoal stick; compressed charcoal pencil.

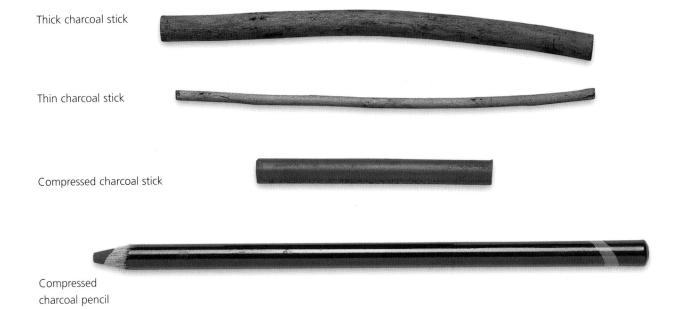

Coloured drawing media

Coloured pencils are as familiar as graphite pencils and are used in the same way. They contain a coloured pigment and clay, together with a binder. They are impregnated with wax to help the pigment hold on to the surface of the support with no need for a fixative. The coloured strip is held in a wooden barrel which, like graphite pencils, can be round, triangular or hexagonal in shape. The coloured strip can vary in diameter from one manufacturer to another, as can the wax content and hardness. Hard pencils will keep their point longer and so tend to be better for linear work or work that entails a lot of crosshatching, while a softer pencil might be better if you are working with large, loosely applied areas of colour. There are also coloured pencils that resemble graphite sticks and consist of a solid strip of pigment.

The range of colours available is extensive. Mixing takes place optically on the surface of the support rather than by physical blending. All brands are inter-mixable, although certain brands can be more easily erased than others; so always try out one or two individual pencils from a range before you buy a large set.

Coloured pencils are especially useful for making coloured drawings on location, as they are a very stable medium and not prone to smudging, so they do not need to be fixed (set).

Huge colour range Artists who work in coloured pencil tend to accumulate a vast range in different shades – the variance between one tone and its neighbour often being very slight. This is chiefly because you cannot physically mix coloured pencil marks to create a new shade (unlike watercolour or acrylic paints). So, if you want lots of different greens in a landscape, you will need a different pencil for

each one.

Water-soluble pencils

Most coloured-pencil manufacturers also produce a range of water-soluble pencils, which can be used to make conventional pencil drawings and blended with water to create watercolour-like effects. In recent years, solid pigment sticks that resemble pastels have been introduced that are also water-soluble and can be used in conjunction with conventional coloured pencils or on their own.

Water-soluble pencils ▶

Like conventional coloured pencils, water-soluble pencils are available in many colours.

Wet and dry ▼

Watercolour pencils can be used dry, in the same way as conventional pencils, to create linear marks (below left) or blended with water to make watercolour-like effects (right).

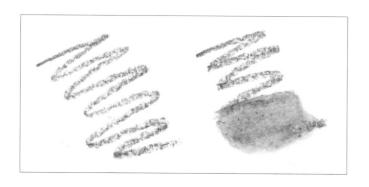

Conté crayons and pencils

Named after Nicolas-Jacques Conté, who invented them in the eighteenth century, Conté crayons are made in a range of traditional colours: white (made from chalk), sanguine (from iron oxide), sepia (from the ink of the cuttlefish) and bistre (from the soot of burnt beech wood). Terracotta, umber and black are also available, as are sets that provide a range of greys and browns. The crayons are also known as carré sticks – carré being the French word for 'square', referring to the square profile of the sticks.

The best way to use Conté crayons is to snap off a small section about 2–3cm (1in) long and use the side of the crayon to block in large areas, and a sharp edge or the tip to make more linear marks.

The pigment in Conté crayons is relatively powdery, which means that, like soft pastels and charcoal, it can be blended by rubbing with a finger, rag or torchon. Conté crayon drawings benefit from being given a coat of fixative to prevent smudging. However, Conté crayons are slightly harder and more oily than soft pastels, so you can lay one colour over another, allowing the underlying colour to show through.

Conté is also available in pencil form in a similar range of colours. The pencils contain wax and need no fixing (setting); the other benefit is that the tip can be sharpened to a relatively fine point.

Pencils and sticks are particularly effective when used together, the pencil being used for precision and detail and the sticks to block in wide areas of tone. Drawings made using both pencils and sticks can be seen to best advantage when made on a light-coloured paper.

Most of the colours that are available in pencil and stick form can also be found in short 'lead' form intended for use in a holder. Different manufacturers make 'leads' in different diameters, so not all are interchangeable. Many of the holders have a sharpening mechanism in the end. Similar square holders are made to hold small pieces of the broken sticks.

Conté crayons ▼

These small, square-profile sticks are available in boxed sets of traditional colours. Drawings made using these traditional colours are reminiscent of the wonderful chalk drawings of such old masters as Michelangelo or Leonardo da Vinci.

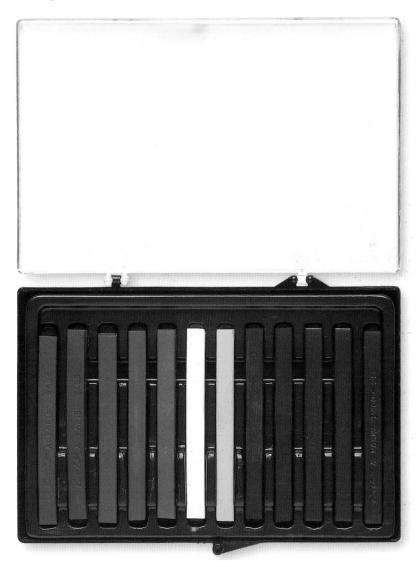

Conté pencils ▼

As they can be sharpened to a point, Conté pencils are ideal for drawings that require precision and detail.

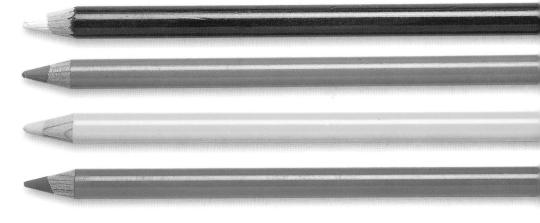

Pastels

Pastel work is often described as painting rather than drawing and it is an unusual drawing medium in that the techniques used are often similar to techniques used in painting. Pastels are made by mixing pigment with a weak binder (usually gum

tragacanth) to hold the mixture together. The more binder in the mix, the harder the pastel. Various amounts of titanium or zinc white can be added to the pure pigment, resulting in a range of pastels of slightly different tints.

Soft pastels

Usually around 6cm (2½in) long and about 1cm (½in) in diameter, soft pastels can also be purchased in half-lengths (shown below), as well as a limited range of much thicker pastels that are ideal if you want to work on a large scale.

As soft pastels contain relatively little binder, they are usually quite delicate and prone to crumbling, so they are wrapped in a paper wrapper to help keep them in one piece. Even so, dust still comes off the pastels, and can easily contaminate other colours nearby. The best option is to arrange your pastels by colour type – all the blues together, all the greens together, and so on – and store them in boxes with shallow drawers. Some artists recommend putting dry rice in the drawer, too, so that any dust comes off on to the rice rather than on to the other pastels.

Because soft pastels are so crumbly, you will find that small pieces break off

as you draw. Often the pieces are so tiny that they are very difficult to hold comfortably for drawing – but don't discard them. Even tiny fragments can be used to block in areas of colour: simply put your finger over the piece of pastel and gently rub it on to the paper.

In some ways, the small amount of binder in soft pastels is a bonus, as it means they are almost pure pigment and hence the colours are very fresh and immediate.

Pastels are mixed together on the support either by physically blending them or by allowing colours to mix optically. The less blending that is done, the fresher the image looks. For this reason, pastels are made in a range of tints and shades that runs into the hundreds.

Pastels are coded for strength and colour. All brands can be mixed and used together, although the coding system used is not consistent across the different brands. The degree of softness

also varies between brands, so it's a good idea to try out a few pastels from one manufacturer's range to see whether or not you like the feel of them before you spend a fortune on buying a large set.

As pastels are a dry, powdery medium, the paper on which you draw must be textured enough to hold the particles of pigment in place. Pastel paper is specifically designed to do this, allowing you to build up several layers of colour.

Remember to spray any soft pastel drawing with fixative to prevent the colours from smudging. You can fix (set) work in progress, too – but there is a risk of the colours darkening, so don't overdo it.

Box of pastels ▼

When you buy a set of pastels, they come in a compartmentalized box so that they do not rub against each other and become dirtied.

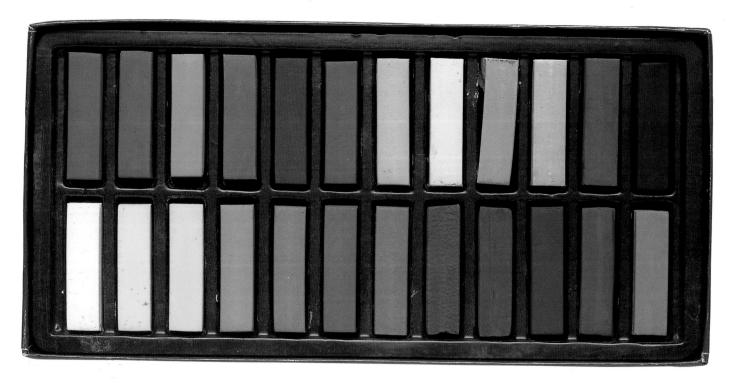

Hard pastels

Formulated slightly differently to soft pastels, hard pastels contain less pigment and more binder. They are easier to control than soft pastels and have the added advantage that they can be carefully sharpened to a point. They are found in a reasonably comprehensive range of colours, but the selection is nowhere near as great as that for soft pastels and the colours are not as pure or brilliant.

One advantage of hard pastels is that, in use, they do not shed as much pigment as soft pastels, and so they do not clog the texture of the paper as quickly. For this reason, they are often used in the initial stages of a work that is completed using soft pastels. Hard pastels can be blended together by rubbing, but not as easily or as seamlessly as soft pastels.

Pastel pencils

A delight to use, the colours of pastel pencils are strong, yet the pencil shape makes them ideal for drawing lines. If treated carefully, they do not break – although they are more fragile than graphite or coloured pencils. The pastel strip can be sharpened to a point, making pastel pencils ideal for describing detail in drawings that have been made using conventional hard or soft pastels.

Pastel pencils ▼

Available in a comprehensive range of colours, pastel pencils are clean to use and are ideal for linear work. They can be used with both hard and soft pastels.

Oil pastels

Made by combining pigment with fats and waxes, oil pastels are totally different to pigmented soft and hard pastels and should not be mixed with them. Oil pastels can be used on unprimed drawing paper and they never completely dry.

Oil pastel sticks are quite fat and therefore not really suitable for detailed work or for fine, subtle blending. For bold, confident strokes, however, they are perfect – so instead of trying to work in a way the medium is not suited to, make a point of exploiting their textural qualities and work on a large scale, using vigorous strokes and building up rich, waxy colour.

Oil-pastel marks have something of the thick, buttery quality of oil paints. The pastels are highly pigmented and available in a reasonably comprehensive range of colours. If they are used on oil-painting paper, they can be worked into using a spirit solvent such as turpentine or white spirit (paint thinner), which you can apply using either a brush or a rag. You can also smooth out oil-pastel marks using your fingers. Wet your finger first: as oil and water are not compatible, a damp finger will not pick up colour.

As with the other types of pastel, oil pastels can be blended optically on the support by hatching or scribbling one colour on top of another.

You can also create a wide range of textural effects by scratching into the pastel marks with a sharp implement — a technique known as sgraffito.

Oil pastels ▼

Less crumbly than soft pastels, and harder in texture, oil pastels are round sticks and come in various sizes. They are sold in a paper wrapper, which helps to keep the pastel intact and the artist's hands clean. Tear away the wrapper as the pastel wears down.

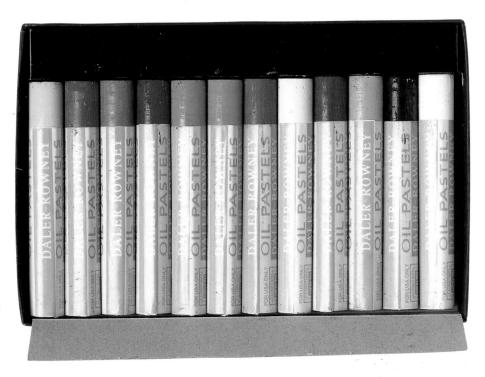

Pen and ink

Working in pen and ink can be a rather frightening prospect for beginners as, if you make a mistake, it's difficult to erase. However, with so many types of pens and colours of ink available, not to mention the possibility of combining linear work

with washes of colour, it is an extremely versatile medium and one that is well worth exploring.

Begin by making a light pencil underdrawing of your subject – but beware of simply inking over your pencil lines, as this can look rather flat and dead. When you feel you've gained enough confidence, your aim should be to put in the minimum of lines in pencil, simply to ensure you've got the proportions and angles right, and do the majority of work in pen.

Inks

There are two types of inks used by artists – waterproof and non-waterproof. Waterproof inks can be diluted with water, but they are permanent once dry, which means that line work made using waterproof ink can be worked over with washes without any fear of it being removed. They often contain shellac and thick applications dry to leave a slight sheen,

which can be slightly distracting.
Perhaps the most well-known
waterproof ink is so-called Indian ink,
which is not from India at all, but from
China. Indian ink makes beautiful line
drawings. Although it is a deep black
when it is used straight from the bottle,
Indian ink can be diluted to give a
beautiful range of warm greys.
Waterproof inks are also available in a
limited range of basic colours that can
be mixed prior to application.

Non-waterproof inks are more difficult to find, but they are worth the effort as they can be worked into once dry. Work can be lightened and corrections made. As with waterproof inks, the colour range is limited.

Finally, do not overlook the potential of liquid acrylics and watercolours. Both are found in bottles and can be used with pen and brush, just like ink. The colour range is slightly more extensive.

Water-soluble ink

Waterproof ink

Dip pens and nibs

Liquid acrylic

A dip pen does not have a reservoir of ink; as the name suggests, it is simply dipped into the ink to make marks. Drawings made with a dip pen have a

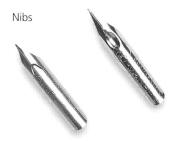

unique quality, as the nib can make a line of varying width depending on how much pressure you apply. You can also turn the pen over and use the back of the nib to make broader marks. As you have to keep reloading the pen with ink, it is difficult to make a long, continuous line – but for many subjects the rather scratchy, broken lines that are produced are very attractive.

When you first use a new nib it can be reluctant to accept ink. To solve this, rub it with a little saliva.

Range of nibs

Dip pen barrels take a range of different shapes and sizes of nib. Each nib makes a different range of marks – and the more flexible the nib, the more variety you can achieve in the thickness of line. To put in a new nib, simply push the end into the slot in the barrel, taking care not to bend it. Not all nibs fit every pen, so make sure you buy nibs that are compatible with your pen barrel. The barrels are made from wood or plastic and are inexpensive to buy.

Bamboo, reed and quill pens

Cut from a short length of bamboo, bamboo pens vary in thickness. Some pens are cut so that a different sized nib is at each end. The nib of a bamboo pen is inflexible and delivers a slightly 'dry', rather coarse line that is completely different to one made using a dip pen.

Reed pens are flexible and deliver a subtle line that does vary in thickness. The nib end breaks easily, although it can be reshaped using a sharp knife.

Quill pens can be made from any reasonably large feather – turkey, swan or goose, for example. The line quality is full of character, making a quill pen a joy to use. The cut nib can break easily but, like reed pens, can be re-cut.

Sketching pens, fountain pens and technical pens

Sketching pens and fountain pens make ideal sketching tools and enable you to use ink on location without having to carry bottles of ink. Use only water-soluble ink in fountain pens, or they will guickly become blocked.

Technical pens deliver ink through a tube rather than a shaped nib, so the line is of a uniform width. If you want to make a drawing that has a range of line widths, you will need several pens with different-sized tubular nibs.

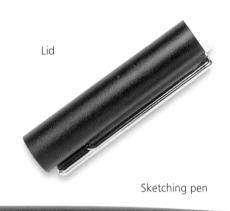

Ink cartridges for sketching pens ▼
Sketching pens hold a cartridge that
contains a specially formulated drawing
ink that will not clog the nib.

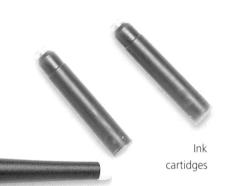

Rollerball, fibre-tip and marker pens

All these types of pen are readily available from both art supply stores and normal stationery stores. Drawings made using a rollerball pen can have a rather mechanical feel to them, as the line does not vary in width, but, by working quickly, you can make a light line by delivering less ink.

Fibre-tip and marker pens nowadays come in an extensive range of tip widths from super-fine to calligraphic style tips and also in a wide range of colours.

While these types of pen may not be suitable for finished artworks, they are certainly very useful tools for working out ideas in sketchbooks and for making preparatory studies. One of the main benefits is that they are so easily portable, as you do not need to carry separate bottles of ink.

Fibre-tip pen ▼

The advantage of fibre-tip pens is that they come in a range of tip widths, so you can use broad tips to block in large areas of tone and fine tips for delicate details. The colour range is also extensive, so they are great for making quick colour notes on reference sketches. Like rollerball and technical pens, they tend to give a drawing a rather mechanical feel.

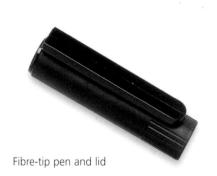

Rollerball pen ▼

For making quick reference sketches or thumbnail compositional sketches on location, rollerball pens are a good option as they are easy to transport and clean to handle.

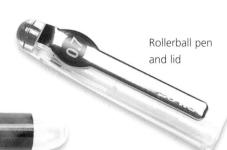

Supports

The general name for the surface on which you draw is the 'support' – usually, but not always, some kind of paper. There are a number of types and qualities of paper available and the

one you choose will depend on both your own personal taste and the subject you are drawing, as well as the medium in which you are working.

White paper

Drawing papers vary enormously in quality and cost, depending on whether the paper is handmade, machine-made, or mould-made.

The thickness of a paper is described in one of two ways. The first is in pounds (lbs) and describes the weight of a ream (500 sheets). The second is in grams (gsm), and describes the weight of one square metre of a single sheet. Sheets vary in size.

Many papers can also be bought in roll form and cut to the size required. You can also buy pads, which are lightly glued at one end, from which you tear off individual sheets as required. One of the benefits of buying a pad of paper is that it usually has a stiff cardboard back, which gives you a solid surface to lean on when working on location and means that you don't have to carry a heavy drawing board around with you. Sketchbooks have the same advantage.

The most common drawing paper has a smooth surface that is suitable for graphite, coloured pencil and ink work. Papers intended for use with watercolour also make ideal drawing supports. These papers come in three distinctly different surfaces — HP (hot-pressed) papers, which are smooth; CP (cold-pressed) papers, also known as NOT, or 'Not hot-pressed' papers, which have some surface texture; and rough papers which, not surprisingly, have a rougher texture.

Art and illustration boards are made from cardboard with paper laminated to the surface. They offer a stable, hard surface on which to work and are especially useful for pen line and wash, but can also be used with graphite and coloured pencil. They have the added advantage of not buckling when wet, as lightweight papers are prone to do, and are available in a range of sizes and surface textures, from very smooth to rough.

Drawing paper ▼

A medium-weight paper is suitable for most purposes, but if you are planning to use water-soluble pencils in combination with water, a heavier paper is best. For fine, detailed work, choose a smooth paper. For charcoal and pastel work, a paper with some 'tooth' to pick up the pigment is generally best.

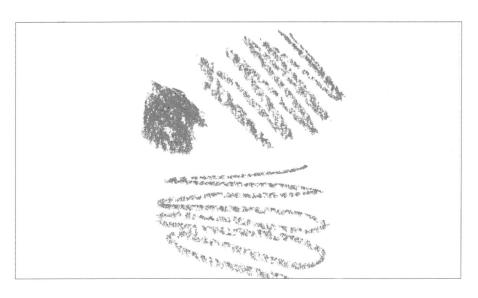

Sketchbooks ▼

Available in a wide range of formats and containing all the above-mentioned papers, sketchbooks are invaluable for working out ideas and for drawing on location. Spiral-bound, stitched or glued, the sketchbook is perhaps the most important piece of equipment for anyone who draws.

Coloured paper

The main advantage of making a drawing on coloured paper is that you can choose a colour that complements the subject and enhances the mood of the drawing. Coloured papers can be used with all drawing mediums. Some of these papers are laid rather than woven. Laid papers can be identified by the network of parallel lines that runs through the paper, which you can see by holding it up to the light.

Some papers are manufactured specifically for use with dusty, pigmented drawing materials such as pastel, chalk and charcoal. They are normally tinted in a range of pleasing natural colours that complement the pastel colours and give an overall colour harmony. Several brands are also available as boards, which makes them relatively easy to use on location.

Pastel papers ▼

Papers for use with pastels are coated with pumice powder or tiny cork particles that hold the pigment and allow for a build-up of colour.

Coloured papers ▼ Available in a wide range of colours with a good, even surface texture, coloured papers can be used with all drawing mediums.

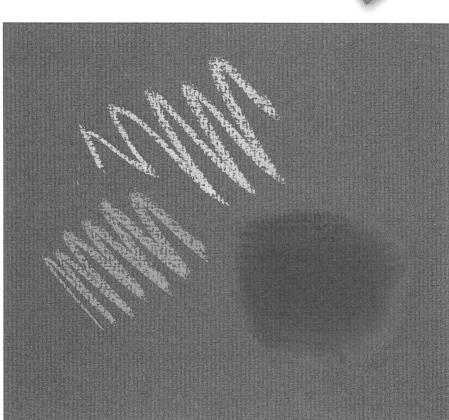

Preparing your own surfaces

It is both satisfying and surprisingly easy to prepare your own drawing surfaces. Acrylic gesso, a kind of primer that is used to prepare a surface such as canvas or board when painting in oils or acrylics, can also be painted on to paper to give a brilliant white, hard surface that receives graphite and coloured pencil beautifully.

To make a surface that is suitable for pastels, you can mix the gesso with pumice powder.

To create a toned or coloured ground, simply tint the gesso by adding a small amount of acrylic paint in the appropriate colour.

Additional equipment

In addition to drawing tools and paper, there are a number of other pieces of equipment that you will need – erasers, tools to sharpen your pencils, blending tools and easels. If you work in very soft mediums, such as charcoal, you will also need fixative. With the exception of easels, most are inexpensive and readily available from both art supply stores and general stationers.

Erasing tools

After tools that make marks, perhaps the next most used pieces of drawing equipment are tools that erase them. Erasing marks is not only a way of making corrections, but also a markmaking technique in its own right.

Kneaded erasers are good for cleaning up areas of a drawing. You can knead them to a point and even pull off small sections for delicate areas of a drawing. They do, however, get dirty very quickly, especially when used with charcoal or pastel.

India rubber, vinyl and plastic erasers are harder and able to erase precise,

fine marks. Large soap-gum erasers are used for cleaning up areas of white paper, as are cleaning pads, consisting of a bag of rubber granules that is rubbed over the paper surface. Erasing knives can be used to scrape mistakes away gently, but they need to be used with care.

Types of eraser ▶

A plastic eraser (top) is hard and unyielding and can be used very precisely to erase small marks and areas. A kneaded eraser (bottom) is pliable and can be pulled to a point.

Sharpening tools

In order to sharpen your drawing tools and to repair and re-cut pen nibs, you will need a sharp craft (utility) knife. There are several types on the market, from those that require replaceable blades to models with retractable blades that break off to expose a new sharp section. Whichever type you use, keep plenty of spare, sharp blades to hand. Using a blunt knife will not only not sharpen your drawing implement well, but it is also dangerous.

Pencil sharpeners are also useful, provided the blade is sharp. Abrasive-paper blocks are another good way of keeping the points of pencils and chalks shaped and sharp.

Hand-held pencil sharpener ▼

Small, hand-held pencil sharpeners are useful but make sure they are large enough to hold the barrel of the pencil.

Craft/utility knife ▼

This knife has a retractable blade. When one section of the blade is blunt, simply snap it off and push the lever on the knife handle to expose the next section.

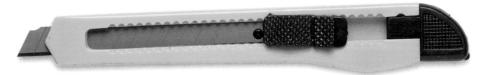

Battery-powered sharpener ▼

This battery-powered pencil sharpener is ideal if you do a lot of graphite or coloured-pencil work, as it sharpens quickly and evenly.

Made from resin dissolved in a colourless spirit solvent, fixative is applied to drawings made with dusty, pigmented materials such as charcoal and soft pastels, to prevent smudging. Fixative is used not only on finished drawings, but also on work in progress to make it possible to build up layers of marks and to preserve areas of a drawing that you are happy with. Fixative is available in aerosol cans (like hairspray which can also be a cheap alternative), bottles with a mechanical spray mechanism or a mouth spray diffuser.

Blending tools

In order to blend marks and manipulate pigment or move it around on the support, you will need to acquire some torchons – also known as paper stumps, or tortillons. These are made from rolled or pulped paper fashioned into a point at one or both ends. They get dirty quickly, but can be cleaned by being rubbed on a sheet of glass paper.

Of course, you can also blend marks with a clean rag or piece of kitchen paper (although this method is best for large areas such as skies), or with your fingertips.

Torchons **▼**

Invaluable for blending dusty, pigmented materials such as charcoal and soft pastels, torchons (also known as tortillons or paper stumps) come in a range of sizes. They are made of tightly rolled paper and have a tapered end (for working on large areas) or a pointed end (for small details).

Drawing boards and easels

If you are working on loose sheets of paper, you will need a drawing board. You may find it worthwhile buying two in different sizes. Boards are made from plywood, which makes them relatively light and easy to use on location. Paper is fixed to the board by means of clips, drawing pins (thumb tacks) or masking tape; clips (see below) are easy to use and do not tear or puncture the paper.

The type of easel that you choose depends on your budget, the space in which you work, the type of work that you intend to do, and whether or not you plan to work on location. Table easels hold a medium-size drawing board and can be positioned so that the drawing surface is anything up to about 45 degrees above the horizontal. They do, however, need to be placed on a flat surface, so are not suitable for location work.

There are two main types of free-standing easel – those that are portable and those that are not. Portable easels are good for location work. Make sure you buy one that is stable when erected and can easily hold the size of support on which you intend to work, at a comfortable angle. Studio easels are a major investment; only buy one if you have room for it. There are two main shapes: an A frame and an H frame. The larger H-frame easels are on castors to make them easier to move and may have a ratchet or winding system to raise or lower the support.

the paper.

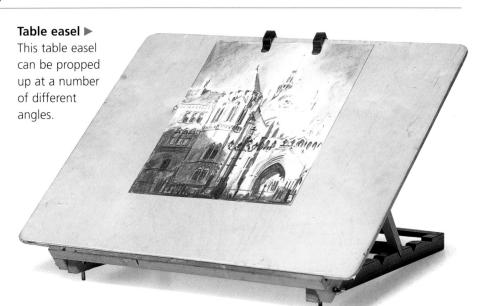

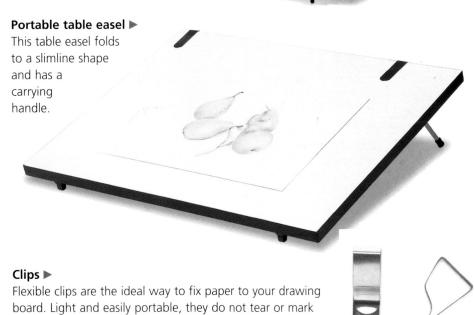

Making marks

The success of your drawings depends on your ability to make as wide and as varied a range of marks as possible. This allows you to exploit the potential of your chosen material to the full. With practice, every drawing tool – even the simple graphite pencil – can be made to produce a surprisingly wide range of marks. Mark-making is something that you can practise whenever you have a few minutes spare; time that you spend doodling on a scrap piece of paper is never wasted.

Several things affect the quality of a mark, including pressure, direction, speed, and the angle at which the drawing tool is presented to the support. Marks made when drawing are used to represent three distinct things: line, tone

and texture. Line is mainly used to describe the shape of a thing. In reality, these lines don't exist, but in the hands of an artist they are a graphic device that indicates where one thing ends and another begins. By varying the quality of a line, however, you can show much more than just the shape of something. You can also convey light, shade, and even the texture of the object.

Tone indicates how light or dark something is, the direction and strength of the light, and the form of the subject. Tone can be applied in several ways. Suffice to say here that being able to indicate tone in a controlled way is very important if you want to portray your subject in a way that looks convincing. Textures indicate the surface quality of

an object and are directly affected by the quality and direction of the light. When a subject is lit from overhead, the texture of its surface can look flat and uninteresting; when lit from the side, that same surface will look dramatic and full of interest. In order to make these different types of mark, you will need to learn how to hold the drawing tool in a variety of different ways. These may feel slightly awkward at first, but with practice they will become second nature.

The shape of the drawing tool dictates the type and range of marks you make. Remember that, with all drawing tools, by turning them in your fingers you can use not only the point but also the side and the edge, allowing it to come into contact with the support in many different ways.

Controlling the point of a pencil By gently cradling a pencil between your fingers, you can manipulate the point of the tool very precisely by using just your fingers and wrist.

Making heavy marks with a pencil By holding a pencil between the tips of your fingers and your thumb, you can bring the side of the lead into contact with the support and make thicker, heavier marks.

Altering the angle at which you hold a graphite stick

By holding a stick of graphite in the same way and altering the angle of the stick in relation to the support as you work, you can create a fluid line that varies in thickness from being as wide as the tapered section of the stick (shown at the top of the image above, and created by pressing the tapered section flat on to the support) to a crisp, thin line made using just the tip of the stick.

Textural marks

By jabbing the dull, blunted end of a thick stick of graphite on to the support, you can make textural marks that vary in tone, depending on how much pressure you apply.

Using the point of a Conté or carré stick

Conté and carré sticks and chalks can be sharpened to various degrees in order to make lines of varying thickness similar to those made with a pencil.

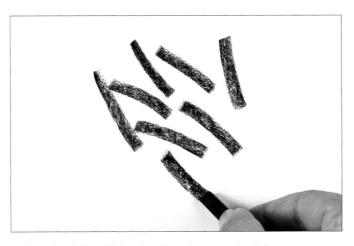

Using the full width of a Conté or carré stick

Here the width of a Conté stick is pressed on to the support to create a broad, dense mark.

Using the flat side of a Conté or carré stick

By pulling the side of a Conté or carré stick across the support, you can lay down a broad area of dense pigment.

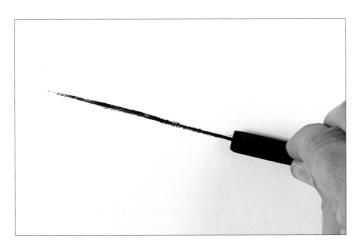

Using the sharp edge of a Conté or carré stick

By holding the stick between the tips of your fingers and your thumb and pulling it lengthways along the sharp edge of one side, you can make a straight line that gradually becomes thicker as the stick wears down.

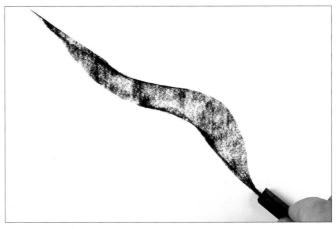

Twisting a Conté or carré stick

By holding the stick between the tips of your fingers and your thumb, pulling it lengthways along the sharp edge of one side, and turning it back and forth, you can create a wave-like line that varies in width from thin to thick and back again.

Line drawing

Lines around an object are merely a graphic device that artists use to describe the shape of things. A good line drawing will guide the eye over and around the subject, inviting you to 'feel' its shape. In order to use line in this way, you need to be able to alter its density and its width. When using dry pigmented materials like graphite, you can make a line darker by

increasing the amount of pressure that you apply. To increase the width of a line, angle the drawing tool so that more of it comes into contact with the support. The quality of a line is also influenced by the speed with which it is made; a line applied with speed and confidence will look strong and fluid, whereas a line applied in a hesitant way looks laboured.

If it is used well, the line can be made to describe light, shade and the texture of your subject. It can also be used to describe internal contours. If an object is drawn in outline only, all you will see is a silhouette-like shape – but if you use line to indicate internal contours, you will have a much better idea of the form of the object that you are drawing.

Practice exercise: Simple line drawing

You can adapt the approach used here to any subject you choose, and it is well worth setting aside ten or fifteen minutes every day to make a sketch like this as there is nothing better for improving your powers of observation and eye—hand co-ordination.

Whatever subject you choose, think of your eye as a laser, moving along the contours of the object and cutting it out. Try to move your eye and your pencil at the same speed, as this will make it easier for you to get the size of different parts of the subject right without having to measure anything. Work slowly to begin with, increasing your speed as you get more confident.

As a variation on this exercise, draw something without looking down at the paper. Don't worry if your lines don't join up: the point is to train yourself to really look at your subject and put down on paper the shapes you can see.

Materials

- Smooth drawing paper
- 4B pencil

The subject

Here, the artist selected a trainer (sneaker) as her subject. The laces and the decorative lines within it help to convey the shape of the shoe.

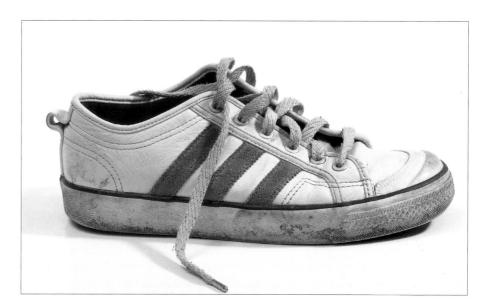

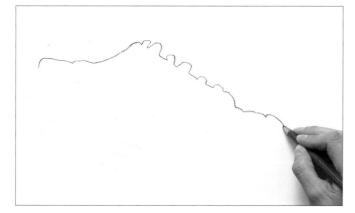

1 Working slowly and carefully, begin drawing the top of the trainer, looking at where the laces form the outer line of the silhouette. Try to think of the laces as being part of the overall shape of the shoe, rather than just things that are attached to it.

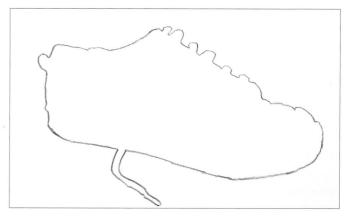

2 Continue around the base of the shoe, concentrating hard. It's very easy to draw something the way you think it ought to look, rather than putting down the shapes that are actually there. Note how the lace breaks the outline. Try to complete Steps 1 and 2 without lifting the pencil from the paper.

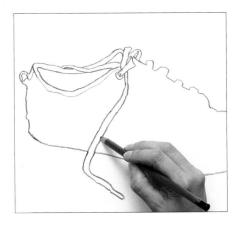

Once the outline is complete, you can begin to put in some of the internal lines such as the lace holes and the long lace that trails over the side of the shoe.

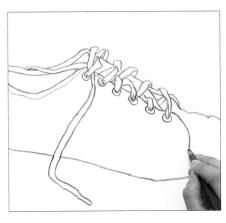

A Now draw the laces, observing carefully how they twist and turn over one another. Also draw the decorative band on the side of the lace-hole panel.

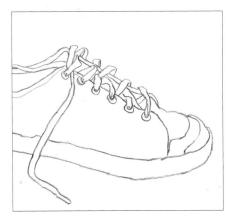

5 Next you will need to put in the broad lines across the toe of the shoe as well as along the raised tread around the base. This helps to give some sense of form.

The finished drawing

The decorative detailing completes the drawing. This is a simple sketch of an ordinary household object, but with just a

few lines the artist has managed to convey both the shape and something of the form of her subject.

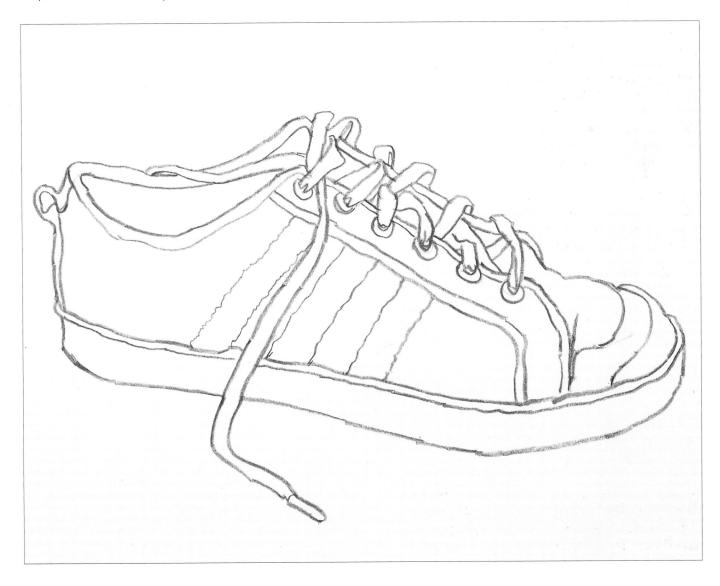

Seeing things as simple shapes

When you first look at your subject, the amount of information that you need to take in and assimilate can seem quite daunting. The answer is to simplify what you see into a series of simple geometric shapes. The shapes most commonly used are the cone, the cylinder, the cube and the sphere – all three-dimensional objects. They may be elongated or compacted, but essentially the shapes remain the same.

Make your initial sketch using these four shapes, or combinations of them, as appropriate. All these shapes are relatively easy to draw in perspective, which will help you to orientate and position the elements within the drawing quickly and correctly. Then you can elaborate, redefine the shape and gradually add tone and detail.

The illustrations on these two pages show how simple geometric shapes (the red lines in the illustrations) can be used as a starting point for drawing a number of ordinary household objects. Adopt the same approach when drawing other subjects; you will find it surprisingly beneficial.

Straight-sided bottle ▼

The shape of this bottle was established by first drawing a simple elongated box in perspective. The top of the bottle was then indicated by drawing a tall cylinder.

Bottle with round base ▼

The round-based bottle shown below was drawn by first creating an egg shape (an elongated sphere). The long neck of the bottle was then added, using a simple cylinder.

Wine glass ▼

The shape of this glass is contained within a cylinder. The bowl of the glass was made using a sphere. Make sure you draw the ellipses for the top rim and the base at the correct angle.

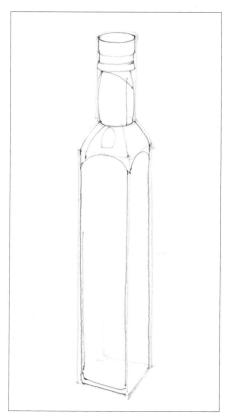

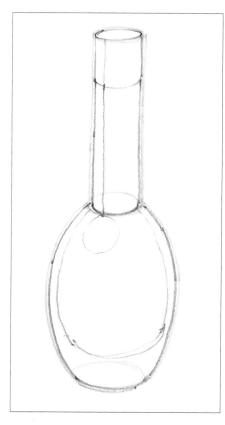

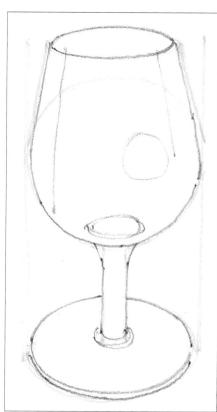

Olive oil pourer 1 ▼

This olive oil pourer was drawn by first sketching a tall cone surmounted by a short cylinder. The spout and handle were added last.

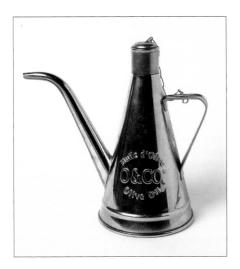

Tip: Even with apparently quite complex-looking objects such as teapots, coffee percolators and oil pourers, keep in mind the four most common geometric shapes: the cone, the cylinder, the cube and the sphere.

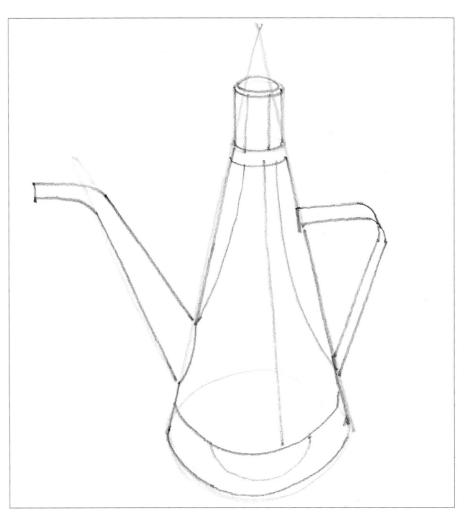

Olive oil pourer 2 ▼ For this pourer two cylinders were drawn, one on top of the other.

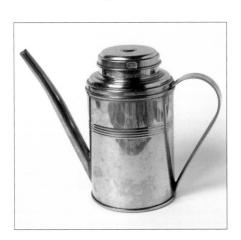

Practice exercise: Reducing a simple still life to basic shapes

Set up a still life with both rounded and straight-sided shapes. Thinking of your subject as a variation on a basic geometric shape will make it easier for you to draw it correctly. It is relatively easy to construct the basic shape of man-made objects using geometric shapes, as these things invariably started life on a drawing board as the same simple shapes that you are using to draw them now.

Materials

- Smooth drawing paper
- HB pencil

The set-up

For this exercise, the artist selected a range of objects from his kitchen that exemplify three of the main geometric shapes – the sphere (an apple), the cone (a coffee pot and a pear) and the cylinder (a coffee cup).

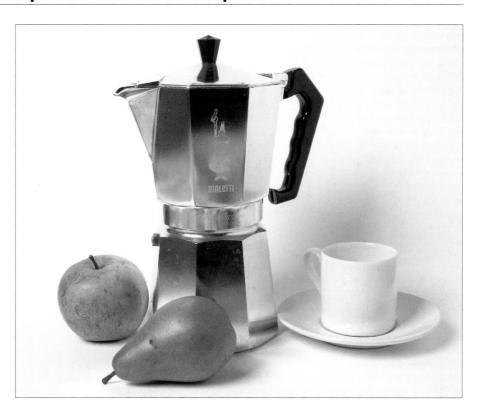

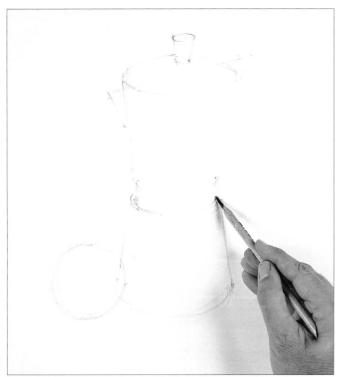

Lightly sketch the objects, thinking of them as simple geometric shapes. Indicate the position of the apple with a circle. The coffee pot consists in essence of two cones, one inverted on top of the other, with a short cylinder at the 'waist' and a small cone for the knob (on the lid). Put in a line across the top of the coffee pot to suggest the axis along which the spout and handle are positioned.

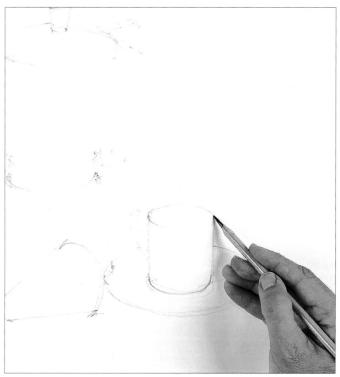

2 You need to indicate the position and shape of the pear by starting to draw a cone. Position the cup and saucer, drawing a cylinder to represent the cup. Note that the lines should be tentative at this stage. All you are doing is trying to search out the essential forms while still thinking of them as basic geometric shapes – the details can be revisited and refined later.

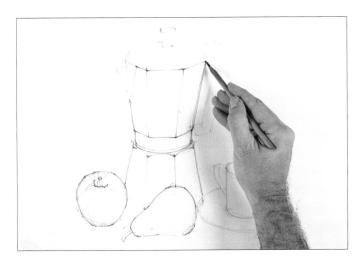

Once you have established the approximate shape and position of the elements, you can begin to refine the objects by drawing over the basic geometric shapes. Make a series of short, straight lines, for example, to establish the different facets of the coffee pot, which has straight sides. Position the stem at the top of the apple. Immediately the objects begin to look three-dimensional.

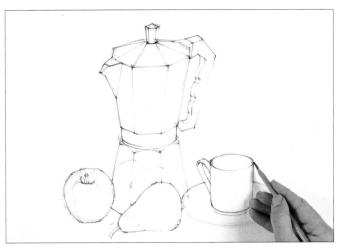

 $\mathbf{4}$ Complete the facets of the coffee pot and put in the ellipses that form the saucer and the top and bottom of the coffee cup.

The finished drawing

Add a few internal contour lines, which indicate the direction and angle of some of the surfaces, to complete the drawing.

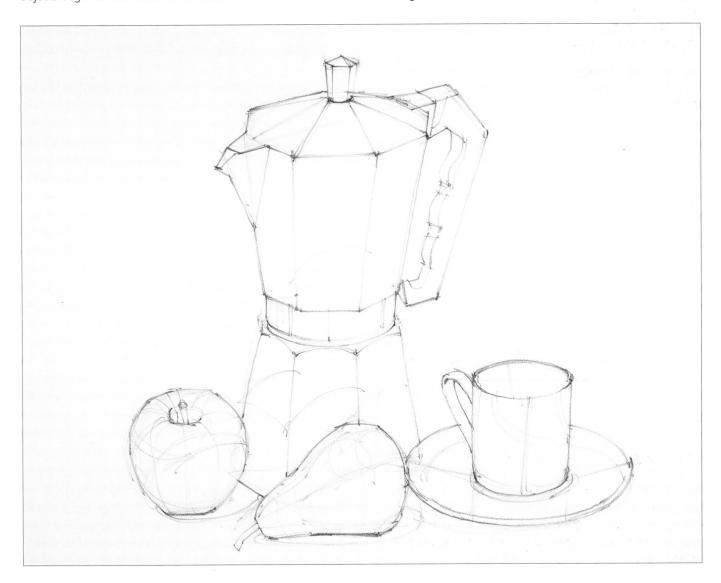

Practice exercise: Simple landscape viewed as geometric shapes

With natural subjects, such as elements of a landscape, it can be slightly more difficult to assign simple geometric shapes to objects. The answer, of course, is not to be too literal. See trees as spheres or cones: the cypress trees in this scene are basically conical in shape, for example, whereas the overall shapes of other trees such as oaks are more rounded. Try to think of any landscape that you are drawing as a series of interconnecting shapes. To practise this, make a series of guick sketches setting down your subjects as rough overall shapes, so that you can fine-tune your eye to this method of working.

Buildings are somewhat easier to deal with, as they are usually designed as geometric shapes in the first place. Most buildings are simply a series of interconnecting rectangles or cubes arranged around one another.

Your aim in the exercise below is not to produce a perfectly finished landscape, but simply to get used to analysing the shape of the things you are drawing.

Materials

- Smooth drawing paper
- 2B pencil

The scene

This is a simple landscape scene of a church in rural Italy surrounded by tall cypresses and shorter, more rounded trees.

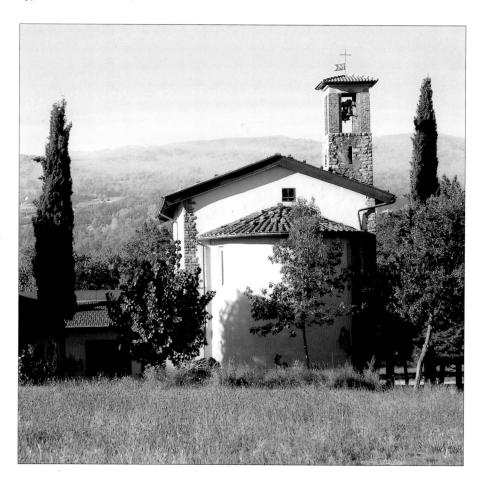

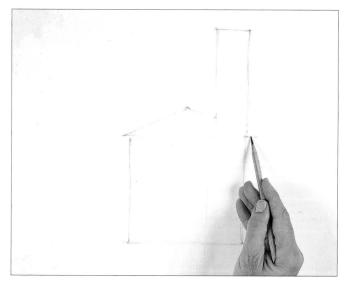

1 First, draw the position and shape of the church. It consists of a rectangle surmounted by a triangular shape that is, in turn, surmounted on one side by the long, thin rectangle of the bell tower. Make sure that the relative proportions of these three shapes are correct.

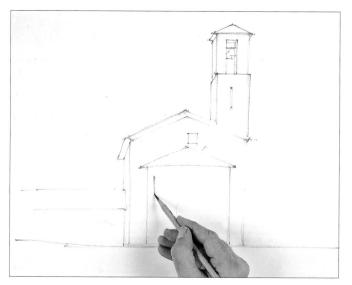

2 Draw the long building that lies to the left of the church as an elongated cube and put in the roof of the tall bell tower. Indicate the apse of the church by lightly drawing another rectangle, surmounting it with a triangle with a slightly curved base.

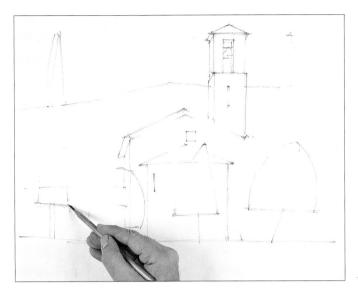

Next, indicate the position and shape of the trees.

Although they do not conform strictly to any geometric shape, with a little imagination they can be simplified.

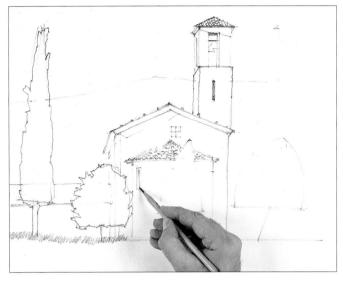

4 Once you have sketched the position and proportions of all the different elements in the scene, use the simple geometric shapes as a guide to refine your drawing.

The finished drawing

With the addition of a little tone, the image comes to life. The tone not only begins to suggest the forms, but also covers up

many of the construction lines that you used to search out the basic geometric forms.

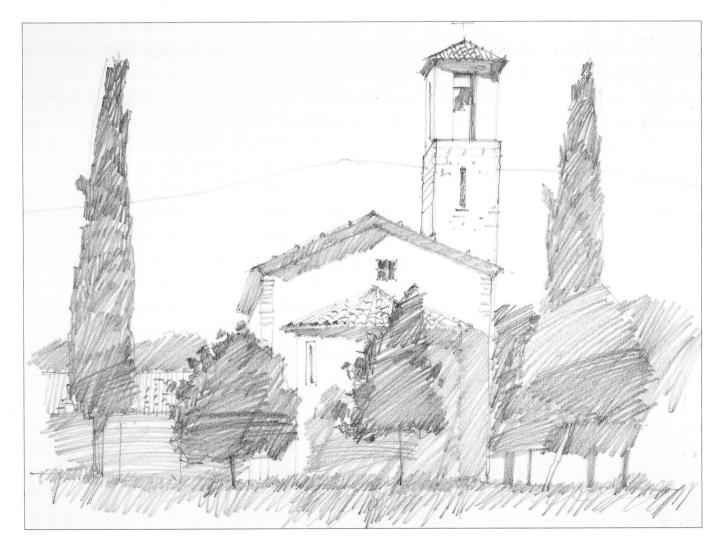

Understanding tone

The term 'tone' describes the degree of dark or light values that the artist uses to create the illusion of form and space in a picture. While it is possible to draw representational images with line alone, this is a more difficult process. Linear drawing encloses plain shapes that may appear to be flat if they are not observed very accurately. The most serviceable method of conveying form, or the threedimensional nature of the subject, is tone. It is the fall of light across the surface of the objects, figure or landscape being drawn that reveals promontories, contours and the negative shapes of space. Even abstraction requires artists to create illusory picture space by using tone.

There are as many methods of creating tone as there are artists, and each beginner must devise a personal method of shading the paper to his or her satisfaction. Examine the works of the great masters for outstanding examples of the use of various media to create tonal values. Try studying the hatched pen drawings of Rembrandt, the wash drawings of Tiepolo, the chalk work of Seurat or pencil studies by Matisse. Whether you study them in books or in galleries, note how tonal density was achieved and choose a preferred method to enable you to find a starting point for toning work.

Once you have devised a way of creating tone, the quality and direction of lighting will also determine the character of the picture. For example, a sunlit rendition reveals the sparkling mass of a rocky outcrop, while storm light enlivens the boiling sea in coastal works. A dramatically lit stage will have more contrast than the calm, steady quality of a day-lit domestic interior.

The illustrations here show a plaster-cast head of the French writer and philosopher Voltaire, lit from different directions. Where light falls directly on the subject, very little detail is discernible. But on the sides that are turned away from the light, strong shadows are formed – and it is these shadows that show up the muscle formation and bone structure, making the cast look three-dimensional.

Light from the left, almost full profile

Here, the light was positioned to the left of the plaster cast and slightly above it. As a result, the forehead is brightly illuminated: the artist left the paper untouched in this part of the drawing. A few faint lines under the left eye hint at the bone structure, but the face is so brightly lit that few shadows are formed here.

On the left side of the head, however, (the right side as we look at it), a mid-tone is used to draw deep shadows that reveal the sunken cheekbones and indentations in the skull. The slab of the neck is drawn using a tone that is even darker, as virtually no direct light hits this part of the cast.

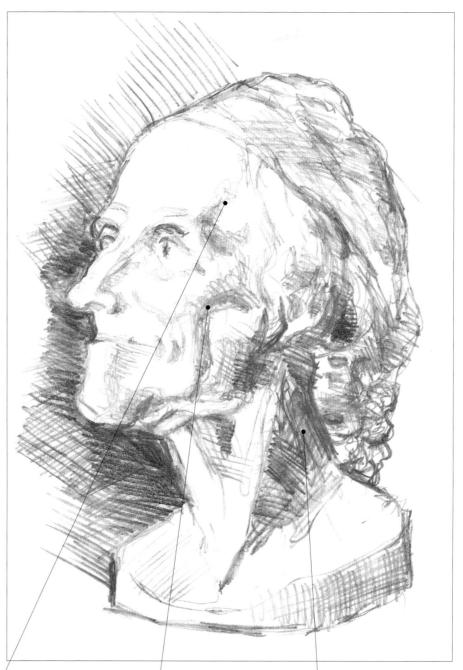

Light pencil marks indicate the change of plane from the brightly lit front of the skull to the side. A mid-tone reveals the structure of the cheekbones, which are in moderate shadow.

Very little direct light reaches the side of the neck and so a very dark tone is used here.

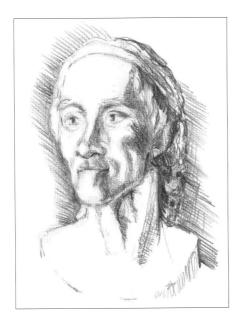

Light from the left, almost full face Here, the head was turned to show more of the face. The light is from the left, so everything on the other side of the rather prominent nose is in shadow.

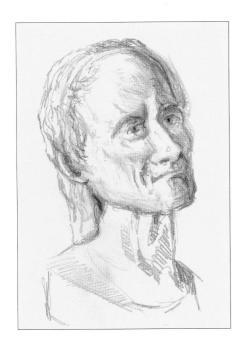

Light from the left, three-quarter view

Here, the light was again positioned to the left of the cast – but slightly lower down than in the previous two images, almost level with the cast, and the cast was turned further to the right. Again, every feature to the right of the nose as we look at the image is cast into deep shadow – but changing the angle of the cast emphasizes different features.

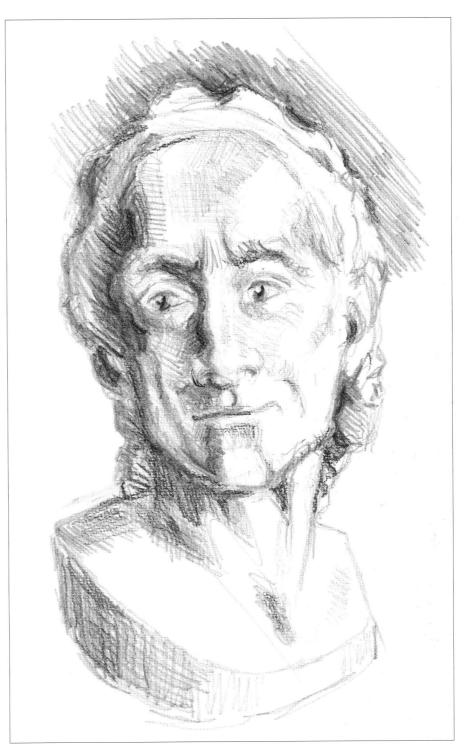

Light from the front, full face

Here the light was positioned in front of the cast – although, to make the drawing more interesting, the artist arranged it slightly to the right instead of placing it centrally, in line with the nose. As a result, the right side of the face (the left as we look at the image) is slightly shaded. The artist used mid-tones to convey this. (Compare this image with the other two on this page, where the light is from the side and the shadows are darker and more intense.)

Note, too, how the frontal lighting has the effect of flattening out some of the features: the cheekbones, in particular, look more rounded and less angular, although this is partly due to the fact that we are viewing the face full on, rather than from the side.

Adding tone

In drawing, the application of tone is sometimes referred to as 'shading', as in 'light and shade'. It is this tone or shading that describes the form of a thing and makes it appear three-dimensional.

The range of tones visible in an object depends entirely on the amount and quality of the light illuminating the subject. A very bright, directional light-source results in a range of tones that run from very dark to very light, with emphasis placed less on the mid-tones and more on the darker and lighter tones. An even but subdued light results in an equally wide tonal range, but with the mid-tones far more evident than strong darks or bright lights. In order to give your two-dimensional drawing the illusion of having the added dimension of depth, you will need to render light and shade convincingly. Fortunately, there are several ways of doing this.

Charcoal: dots and dashes

With soft materials such as charcoal or soft pastels, you can use dots and dashes to create tone. To make the tone darker or lighter, apply more or less pressure.

Charcoal: blending

With very soft, highly pigmented drawing materials, the drawn tones can be blended together using your finger, a torchon or a rag. Drawings like these are quite delicate and need to be fixed to prevent them from being smudged.

Graphite: scribbled tone

With a graphite pencil, you can scribble on tone. For a darker tone, vary the direction of the marks and the amount of pressure.

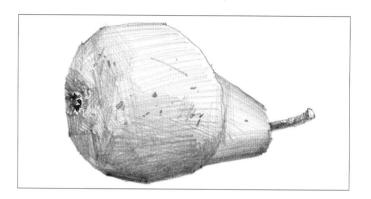

Graphite: contour shading

In contour shading, simple linear marks are made to follow the form of the object. This is sometimes called bracelet shading and can be seen on many old master drawings.

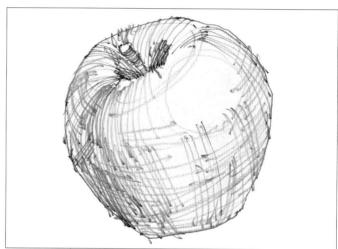

Graphite: crosshatching

With pens and pencils, you can create tone by drawing a series of parallel lines. Crosshatching consists of another series of lines drawn across the first set at an angle. To darken the tone, draw lines closer together and apply more pressure.

Chalks on a mid-toned ground

With chalks or charcoal, a particularly efficient way of achieving a tonal drawing is to work on a mid-grey ground (a ready-toned paper). Establish the mid- and dark tones first before bringing the whole thing to life by adding the lighter tones and the highlights.

Ink: controlled hatching

When using a pen with a fixed-width nib, you can create tone by using hatched and crosshatched lines. To build up the depth of the tone, simply draw the lines closer together. For light areas and highlights, leave the paper untouched so that the white of the support stands for the brightest areas.

Ink: pen and wash

You can create tonal washes by diluting ink with clean water to differing degrees. These ink washes can be used on their own to build up the drawing or contained by linear work made using a dip pen.

Practice exercise: Shading straight-sided objects

For your first practice exercises in shading, select straight-sided subjects and light them strongly from one side, as this makes it easier to see where changes in tone occur. You can find lots of suitable subjects around the home; books, stacked boxes in varying sizes, a pile of CD cases arranged so that they cast shadows on the table top and background, or children's play bricks would all make good subjects.

Start with a monochromatic object. As soon as you introduce different colours things become more complicated, as you are distracted by the colour and will probably find it harder to work out how light or dark the tones need to be.

Materials

- White pastel paper
- Thin charcoal

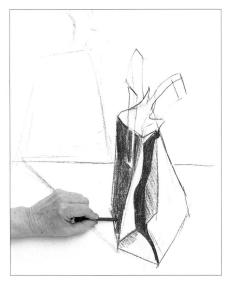

Half close your eyes to assess the tones and work out which areas of the bag are the darkest. (In the set-up shown here, you can see that the back of the bag and the cast shadow in the folded side of the bag are the darkest.) Roughly block them in, using the side of the charcoal stick. Don't make them too dark, however: if necessary, you can always darken the drawing later once the mid- and light tones are in place, but if you make it too dark to begin with, you will find that it's much more difficult to lighten it.

The set-up

The subject chosen for this exercise is a brown paper bag, which has a number of creases and folds within it. The lighting from the side creates interesting cast shadows on both the table top and the wall behind.

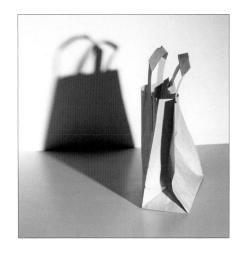

1 Using a thin charcoal stick, map out the composition, making strong lines for the bag and lighter ones for the cast shadows.

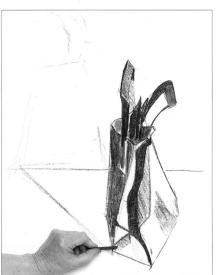

Put in the darkest tones and the mid-tones on the handles. The handles are twisted, so different facets catch the light in different ways, hence the differences in tone. Again using the side of the charcoal stick, put in the dark and mid-tones on the front and side of the bag. You can see how shading provides us with information about the form of the bag: without these subtle differences in tone, we would have no way of knowing how the handles are twisted or where the creases in the bag occur.

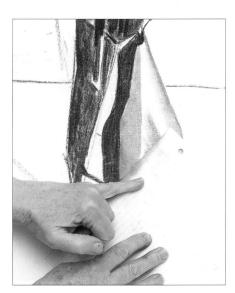

Line up a piece of scrap paper along the bottom edge of the bag and hold it firmly in place. Gently smooth out the mid-tones. (Use your little finger, as it is the coolest and driest part of your hand.) The scrap paper helps you to maintain a crisp edge to the bag; if your finger goes beyond the edge of the bag when you're blending, the charcoal will dirty only the scrap paper and not the background to the drawing. Blending also gets rid of the harsh, drawn line around the edge of the bag.

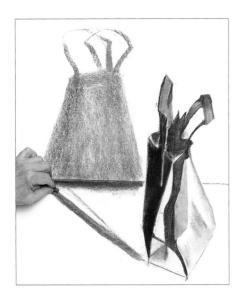

5 Using the side of the charcoal stick, block in the cast shadow on the wall. Block in the cast shadow on the table top, making it darker than the shadow on the wall.

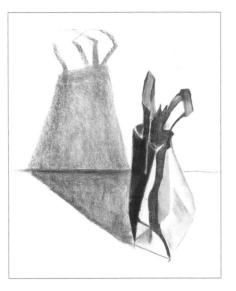

6 Using your fingertips, smooth out the cast shadow on the table top to create an even tone. Do not blend the cast shadow on the wall: the texture of the paper adds interest to the drawing.

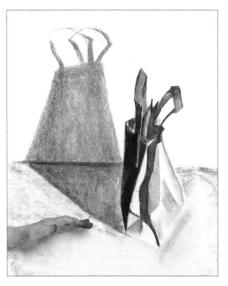

Zusing the side of the charcoal, apply a very thin covering over the table top. Blend it with the side of your hand, using a circular motion, to create an even, pale grey tone.

Draw in the very thin cast shadows underneath the bag on the table top to anchor the bag and prevent it from looking as if it is floating in space.

The finished drawing

The drawing looks convincingly three-dimensional, and the tones range from a very dense black on the back of the bag to a very pale grey (barely darker than the paper) in the most brightly lit areas. Note the use of finger blending – a good way of creating areas of smooth tone when using a powdery medium such as charcoal or soft pastel.

The texture of the paper is visible in parts, adding interest to the drawing.

In a tonal drawing, the darks are almost always darker than you expect them to be. The darkest areas are a very dense black.

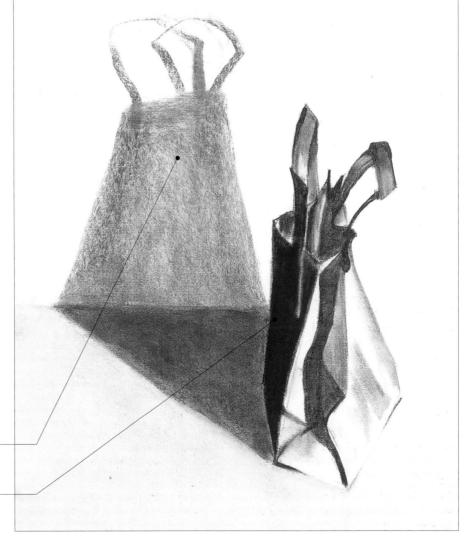

Practice exercise: Shading rounded objects

Straight-sided objects have very clearly defined planes and it is easy to see the sudden fall-off of light. With rounded objects it is much more difficult, as there is no immediate transition from one tone to another. Nevertheless such a transition does occur, even though it happens very gradually. Look for the extremes of tone – the very lightest and darkest areas – and then let your eye travel over the rounded form to assess the degree of change that will be required.

Materials

- Smooth drawing paper
- Graphite pencils: HB, 4B
- Graphite stick

The set-up

The overall composition of this grouping is triangular in shape. The wedge of cheese and the salami point towards each other, drawing the viewer's eye into the scene. The large, rounded loaf of bread balances the smaller objects.

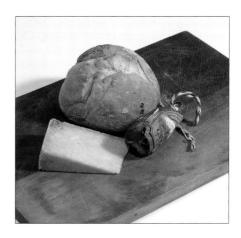

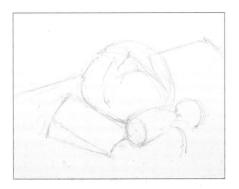

1 Using an HB graphite pencil, lightly sketch the composition. Don't attempt to put in any shading at this stage. Instead, think of the objects as simple geometric shapes and concentrate on getting the sizes and shapes right. Also put in the cracks in the top of the loaf of bread.

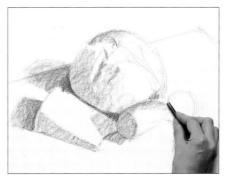

2 Using the side of a graphite stick, block in the mid-tones on the items and the cast shadows. As the loaf is rounded, the transition in tone from the front to the back is gradual. Putting the mid-tones in at this stage makes it easier to judge how light and dark the rest of the drawing needs to be.

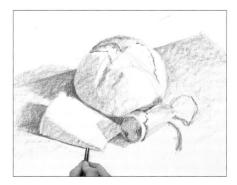

3 Still using the side of the graphite stick, shade the darkest parts of the wooden board behind the bread. Using the tip of the stick, reinforce the dark cracks in the top of the bread and put in the string of the salami and the deep shadow under the wedge of cheese.

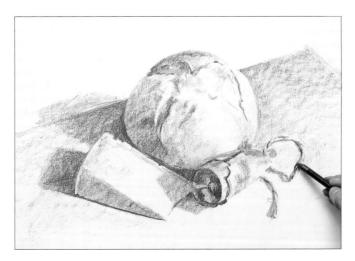

4 Using the tip of the 4B pencil, carefully darken the shaded areas between the objects. In addition to telling us about the quality and direction of the light, these areas also help to anchor the objects on the surface. Put in more linear detail on the salami and its string.

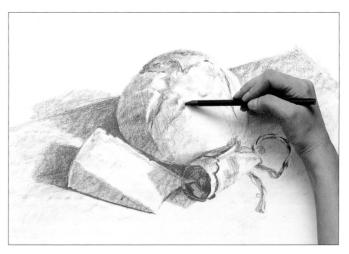

5 Shade the wooden board within the loop of string. Note that this area is lighter in tone than the board behind the bread. Go over the darkest part of the bread again, drawing fine hatching lines close together. Don't bring the lines too far forwards, as the front of the bread is very light in tone.

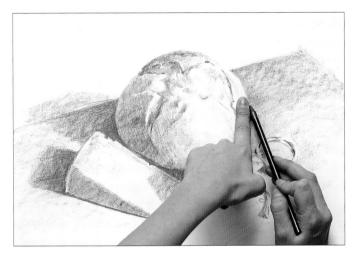

6 Repeat the hatching process on the shaded side of the cheese. Darken the board up to the edge of the bread by placing your finger on the curve of the bread and shading right up to your finger. This allows you to maintain the curve of the loaf without having to draw a harsh line around the edge. (You will have to move your finger around the loaf, following the edge very carefully.)

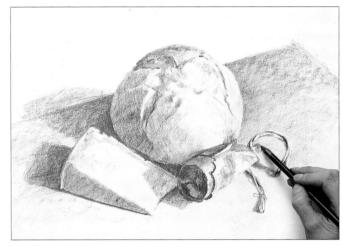

Put in any final linear details on the salami wrapper and its string. Finally, use the 4B pencil to put in the small shadow cast by the string on the wooden board, so that it is clear that the string forms a loop that is raised up above the surface of the board.

The finished drawing

A number of shading techniques have been used in this drawing, including loosely scribbled tone using the side of a pencil or graphite stick on the wooden board and cheese, and hatching on the darkest areas of the loaf. There is a very marked difference in tone between the light and the

shaded sides of the wedge of cheese. The transition from dark to light tone on the rounded objects (the loaf and the salami) is much more gradual, but it has been very carefully observed to make them appear convincingly three-dimensional.

Parallel lines hatched close together form a dark tone on the shaded side of the bread.

The very brightest areas on the front of the loaf contain hardly any tone; the paper is left blank.

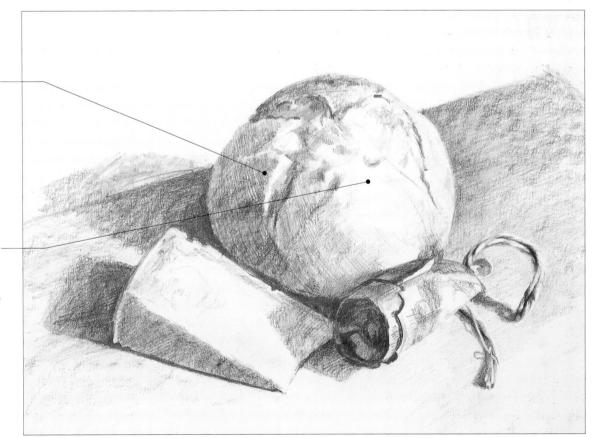

Measuring systems

Getting the proportions and relative size of your subject right is essential in representational art and, unless you have some means of checking measurements, it's almost inevitable that you will make some mistakes. There are a number of well-established measuring systems that you can use and two of the most common are described here.

The most important thing is to learn to trust your measurements rather than your instincts or prior knowledge of a subject. You may be surprised to find when drawing a portrait, for example, that the base of the eye socket is generally about halfway down the face – but if you don't actually measure the distance, you'll probably draw the eyes too high up.

Your viewpoint in relation to your subject and the angle at which the subject is positioned can also make a huge difference to how things appear. Say, for example, you're drawing an avenue of trees receding away from you into the distance. They may be roughly the same height and spaced the same distance apart, but the ones that are furthest away will appear to be smaller and the gaps between them will appear to decrease with distance - so you must measure the relative sizes and follow your measurements. Similarly, if you look at something like a table, you might be tempted to draw it as a rectangle, because you know that's what shape it is - but if you're looking at it from the other side of a room, you'll be seeing it in perspective, rather than from above, and so its shape will be very different.

Get into the habit of taking measurements of everything you draw, whether landscape, still life or portrait. It may seem complicated at first, but as you gain experience measuring techniques such as these will become second nature. It's also important to keep re-checking measurements as you work on your drawing. As you refine a drawing it is very easy to emphasize one element at the expense of another, but a little time spent double-checking that the proportions are still correct could save you a lot of trouble in the long run.

Using a grid

When working from a photograph this is relatively easy. Simply divide the photograph into a grid of squares, and divide your paper into the same number of squares, making the squares larger if you want your drawing to be larger than the photograph and smaller if you want it to be smaller than the photograph. Then copy the image one square at a time.

You can use the same principle when working from reality. Cut a rectangle out

1 Using a craft (utility) knife and steel rule on a cutting mat, cut a rectangle out of the middle of the card (stock).

of the middle of a piece of card (stock) and stretch a series of rubber bands across the aperture to form a grid, spacing them evenly. Draw the same grid on your paper at the size you wish the drawing to be, and then position the grid so that you can look through it at your subject. In order for this to work, you must position the grid so that it lines up with the subject in exactly the same way every time you look through it.

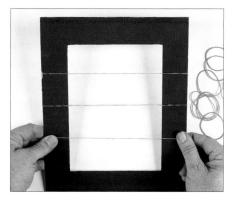

2 Stretch rubber bands across the width of the aperture, making sure they are evenly spaced.

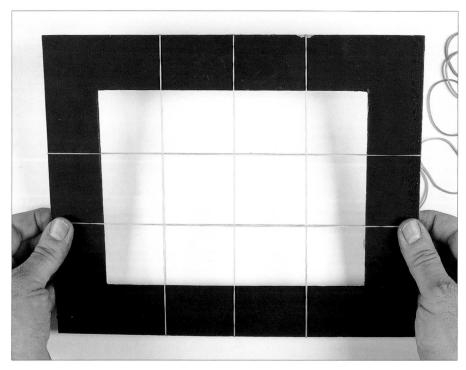

 $\bf 3$ Do the same across the height of the aperture, spacing the bands the same distance apart as in Step 2.

Using a pencil to measure

An alternative method is to use a measuring device – usually the instrument with which you are drawing. Hold the pencil out at arm's length, so that you can see past it to your subject. Choose a part of your subject to measure; this can be the whole length or width of the subject or just a small section. Align the top of the pencil with one end of the distance you are measuring and move your thumb up or down the shaft of the pencil until it is level with the other end of the distance being measured. Now transfer these measurements to your drawing; a small guide mark is sufficient, as you will add detail later once you are sure the proportions are correct. For your first attempts at measuring using this method, work so that you can put marks down directly on the paper at their actual size, without having to scale them up or down to fit.

When using this method, it's absolutely vital that you keep your arm straight, so that the pencil remains a constant distance from the subject. Close one eye to make it easier to focus, and concentrate on looking at the pencil rather than at the subject.

The subject (right)

Here, we used a small statue as the subject, but the principle remains the same whatever subject you are drawing.

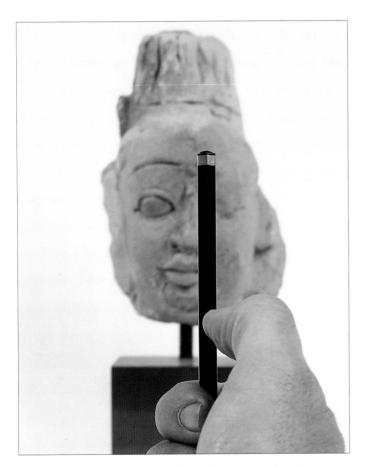

1 Holding the pencil at arm's length, measure the chosen section of your subject – here, the distance from the statue's eyebrows to the base of the chin. Then transfer this unit of measurement to the paper.

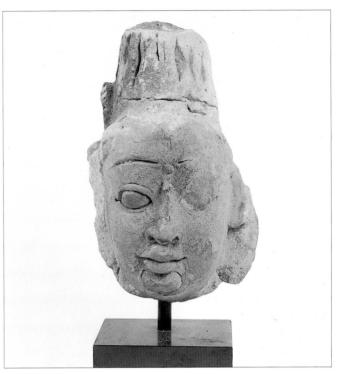

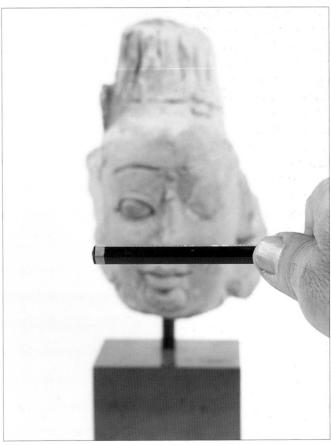

2 Use the same unit of measurement to compare the size of other parts of the subject. Here, the distance across the widest point of the statue is the same as the measurement taken in Step 1.

Negative shapes

The term 'negative shapes' is used in art to mean the spaces between objects in a composition or between different parts of an object. But how does this help you when drawing? It's all about making yourself really look at your subject, rather than relying on your preconceptions about how things should look.

A lot of this has to do with the way that the different hemispheres of the brain work. The left side of the brain is concerned primarily with verbal skills, and it is this side that is dominant in many adults, as we're brought up to express ourselves verbally rather than visually. This means that when we look at something we tend to concentrate on the things we can name – the 'positive' shapes. So if we're looking at a tree, our brain registers things like the trunk and the branches rather than the spaces between the branches, which have no name.

Looking at the negative shapes forces us to switch our thinking from the left side of our brain (the verbal side) to the right side (the visual side). Instead of concentrating on the things we can give a name to and thinking, for example, 'I'm going to draw that square table', we have to say, 'I'm going to draw that straightsided shape'. So we're much more likely to observe and put down correctly the relative shapes and sizes if, instead of being distracted by our knowledge of the fact that all four legs of the table are the same size and shape, we really look at the shapes of the spaces between the legs. Because we're looking at the table in perspective, they appear to be different sizes and positions in relation to one another - and you need to get this across in your drawing in order for it to look realistic.

In the following exercises, you will draw by looking only at the negative shapes. To prepare for them, spend plenty of time looking at the subject before you put pencil to paper. Really force yourself to look at the spaces instead of at the objects. It takes a lot of concentration, but if you try hard you'll find that these negative shapes suddenly 'pop' out at you – rather like a camera lens shifting focus from subject to background.

Practice exercise: **Drawing a straight-sided object using negative shapes**

In this exercise, your task is to draw using only the negative shapes — the spaces around and between the different parts of the chair. It's an artificial way of working (in practice one would alternate between the negative and positive shapes), but it will help fix the principle in your mind. It doesn't matter whether you draw the negative spaces around the outside the chair first and then those within it, or vice versa.

Materials

- Smooth drawing paper
- Graphite stick

The subject

With a straight-sided subject such as this folding chair, the negative shapes are relatively simple to draw.

1 Look at the space to the left of the chair and concentrate until you feel you are able to see it as a shape in its own right, rather than an area of nothingness with the chair along one edge. Then begin drawing the outline of the negative shapes that you can see, concentrating on getting the angles of the shapes and the length of each side of each shape right.

Now move on to the negative shapes within the chair itself – the spaces between the bars of the backrest, the space between the backrest and the seat, and the spaces under the seat between the supporting side bars. Provided you've made your measurements accurately, drawing the negative spaces defines the shape of the subject – the chair.

When you've laid down the basic negative shapes, you can begin to refine the drawing and look at the positive shapes – the different planes of the seat of the chair, for example.

Put in the remaining positive shapes, such as the rivets that connect the side supports to the seat, and detailing, such as the tongue-and-groove effect on the seat. Also carefully draw in the different facets of the side bars and the connecting struts so that the chair looks three-dimensional.

The finished drawing

The subject is simple, but it still requires concentration to draw the relative angles and sizes of all the components accurately. As the chair has straight sides the negative spaces, too, are straight-sided – which makes it easier to see and measure them accurately. Even though no shading or tone has been used, careful measuring of the different elements has resulted in a drawing that looks three-dimensional.

The negative shapes are mostly four-sided or triangular, which makes them simple to measure.

Drawing the negative shapes makes it easier to get slopes and angles right.

Practice exercise: Drawing rounded objects using negative shapes

Use the same approach for this exercise, drawing the spaces between the Chinese lanterns rather than the lanterns themselves. This time the objects are not straight-sided, so this drawing is a little more complex, but the theory remains the same. Again, begin by concentrating on the negative shapes until you feel you see them in their own right and the lanterns appear to recede away from them.

Materials

- Smooth drawing paper
- Soft pastel

The subject

Arrange your subject on a plain background (a large sheet of white paper will do) so that there is nothing that will distract you from looking at the shape of the spaces. If necessary, twist the twigs and Chinese lanterns so that the spaces between them form more interesting shapes.

1 Using the side of a soft pastel, block in areas of colour for the shapes of the negative spaces. Here, the artist is working to the right of the twig that runs down the left-hand side of the composition. The triangle formed where the two twigs meet is a strong negative shape to start with.

Working slowly and methodically, continue blocking in the negative shapes using the soft pastel, while making sure that you leave the correct amount of space for each positive shape (the lanterns). Here the artist is working along the top area of colour.

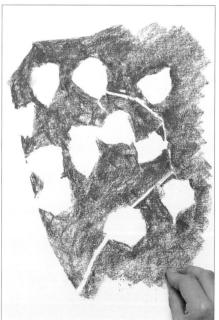

Build up the drawing methodically, remembering to measure the all negative spaces carefully. Look at where the negative spaces butt up to the edge of the twigs, in particular, and concentrate hard to ensure you don't make the twigs too thick.

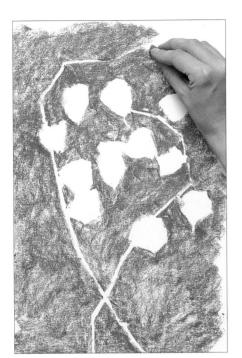

Continue until the only areas untouched by pastel are the positive shapes. Use the side of the pastel, rather than the tip; if you use the tip, it's more likely that you'll be tempted to draw the stalks rather than the spaces on either side of them.

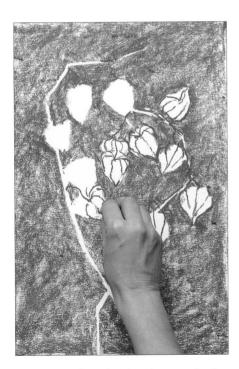

5 To complete the drawing, put in the striatians on the papery outer covering of the lanterns. Look carefully to see how they twist and turn, as this is what will make the lanterns look three-dimensional.

The finished drawing

The shapes of the lanterns stand out clearly. Even without putting any tone or shading on the drawing, a few simple curved lines on the lanterns are enough to give them some form.

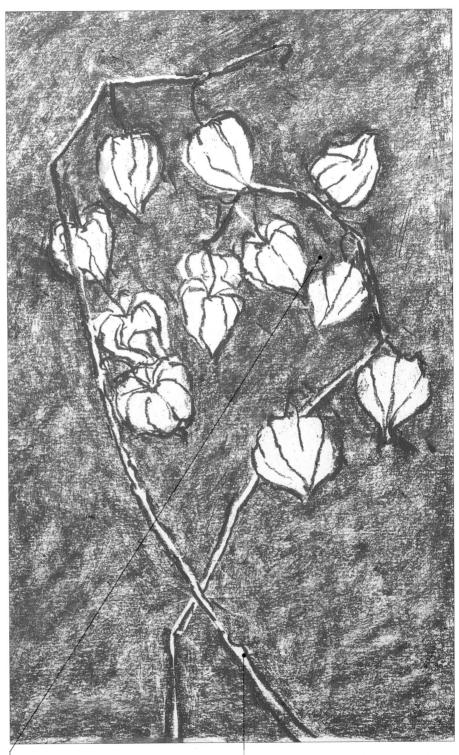

The Chinese lanterns are irregular in shape, so the negative shapes are irregular, too.

The stems are thin and slightly gnarled. Observe the negative shapes leading up to them very carefully.

Perspective

One of the major challenges in learning to draw is how to create the illusion of spatial depth on the flat, two-dimensional surface of a piece of paper. For example, if you're drawing a landscape with a boulder in the foreground and a mountain range in the distance, how do you make it look as if the boulder is near by and the mountains are far away?

Over the centuries, many different drawing systems have been devised to help create the illusion of spatial depth. One approach is to employ a vertical arrangement, with the most distant elements of the scene at the top of the picture space. For example, traditional Chinese brush-drawn landscapes place mountains at the top, with forested lower

slopes under the peaks and a lake or river, perhaps with a boat, in the lower portion.

In Western art, changes in tone and scale are usually employed to create the impression of distance. Whole books have been written about the technicalities of perspective, but the basics are relatively easy to understand. Keen observation of your subject is the key to success.

Aerial perspective

Aerial, or atmospheric, perspective exploits apparent differences in tone between nearby and distant objects to create a sense of depth and recession. When seen from close by, dark-coloured objects or areas cast in shadow appear strong in tone. In the middle distance, darker areas appear less sombre. Further off, rich darks will be perceived

as more muted; and from a great distance, they will acquire a pale, bluish tinge. This filtering effect is caused by the dust, motes, moisture particles and other pollutants in the atmosphere, which cloud the air with tiny particles and partially obscure the far distance. This device has been much used in Western art

Tonal differences for distance

Note how effectively differences in tone create the impression of distance in this drawing. Looking along the strand, the nearest beached boats are the darkest in tone. Further along the foreshore, distance softens strong tonal values, and most distant still, the coastline and ocean are much lighter in tone.

Softly-toned haze

In damp, misty weather, or when a heat wave has drawn moisture up as a heat haze, landscapes will show the softening, or blueing, of distant strong tones. In this scene the shadowed trees and foliage framing this old house which would appear sombre were they close at hand, are seen as relatively softly toned in the middle distance and pale when viewed from afar. The transitions in tone are subtle, but essential in creating an impression of distance.

Tips: If you are working in colour, you also need to think about the temperature of the colours you use.

- Distant objects tend to look 'cooler' and bluer in tone than those that are nearer.
- Skies generally appear paler near the horizon of a scene.
- Include more texture in the foreground of a scene for example, spiky grasses in the foreground of a landscape; the viewer will assume that the textured areas are in front.

Vertical perspective

In this sketch, after the Japanese artist Hiroshige's 'Winter: Scene on the Sumida River', the illusion of depth is created by means of vertical perspective, or placing the most distant elements at the top of the picture space. The boatman is placed on a raft low on the torrent, creating the impression that he is in the foreground, while the near-distant trees are higher in the picture and the far-off mountain is above them, conveying a plausible sense of recession.

Linear perspective

Objects appear to be smaller the further away from you they are. You can use this effect in your drawings to create the illusion of distance.

Linear, or one-point, perspective applies when all the receding planes are aligned and parallel. To see this, look straight down a road where only one façade of the buildings on each side is visible. The horizontal planes of the upper floors above eye level will appear to slope down through the length of the street, although, in fact, they do not get lower. Horizontal lines below eye level will be seen to slope upwards, while in reality the planes remain level. These are the illusions that must be reproduced if the viewer of the picture is to be convinced that the road is receding into the distance.

To determine the correct slant for the horizontal planes, one-point perspective may be plotted to a notional spot known as the vanishing point. A person of average size, looking straight ahead on the flat, will see the horizon at

about 3 miles (5km) away. To make a perspective drawing, plot the imaginary horizon at eye level and mark on it the vanishing point – the place at which all the horizontal lines would meet if they were extended as far as the horizon. Adhere carefully to the plotted lines and you will create the effect of recession. Note that this rule affects only the horizontal elements: verticals must remain upright.

Street scene in single-point perspective

In this scene, all the horizontal elements above eye level (for example the roof lines and the tops and bottoms of the windows) appear to slope down towards the vanishing point, while those below eye level seem to slope up – although, in reality, the planes remain level along the road. If the houses were shown with equidistant planes (that is, without the lines of the roof and road appearing to slope towards the vanishing point), they would not look as if they were parallel to the viewer.

The roofs and many of the windows are above eye level and appear to slope down as the street recedes.

The pavement is below eye level and therefore appears to slope upwards as the road recedes.

Single-point perspective with right angles

Here, too, single-point perspective is used to plot the lines of the buildings and indicate distance. The people furthest away are also drawn smaller than those in the foreground. At the end of the road, another street runs at right angles to the street on which the drawing is made; as this second street is parallel to the picture plane, it has no vanishing points. If the sides of the neoclassical-style building on this second street were visible, the extensions of the horizontal planes would converge on the same single vanishing point as the road from which the scene is viewed. If further streets at right angles to the road were visible, decreasing size and softer tones would also give clues to distance.

Vertical elements remain vertical: only horizontal lines converge on the notional vanishing point.

This road is parallel to the picture plane and therefore has no vanishing points.

The single point pespective combined with a larger structure.

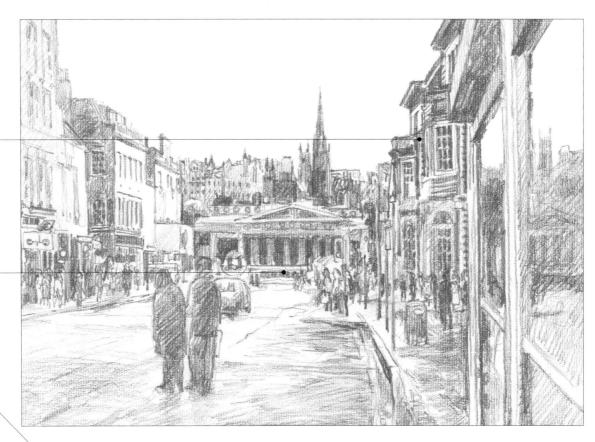

Creating drama

Dynamic compositions can be achieved when single-point perspective is combined with larger structures that are parallel to the picture plane. In this example (left), the design focuses attention on the junction between the brick-and-timber gatehouse wing, on the left of the picture, and the half-timbered block at the back of the courtyard.

The courtyard background appears four-square to the viewer, while the sloping lines of the gatehouse wing (which is seen in single-point perspective) help to direct the viewer's eye through the scene.

In a similar fashion, the lines of the courtyard paving stones, which are also drawn in single-point perspective, help to guide our eye to the figure standing towards the far end.

Two-point perspective

Few constructed environments make interesting compositions unless they involve more than one vanishing point. Once you have tried and understood single-point perspective, you will soon find that multi-sided buildings, or those whose elevations are not all in the same parallel plane, hold more exciting design possibilities. In single-point perspective, the apparent size of forms reduces evenly, as do the spaces between. While this is also true of two-point, or multi-point, perspective, different avenues of vision receding in less depth or at differently oblique angles may appear to diminish to differing degrees.

Remember that in plotting the vanishing points in two- or multi-point perspective, not all the points will fall within the picture space. Clearly, those that are four-square to the picture must be drawn as rectilinear, but those close to square on will have vanishing points far beyond the edge of the image. To discern these, you may need to make a preliminary sketch on a small scale and affix it to a large sheet on which you can plot the angles of recession to the vanishing points. You can then transpose the correct angles from the thumbnail sketch on to the larger-scale support on which you intend to draw for the finished work.

Several vanishing points in the same scene

Multi-point perspective will be used if a building is viewed at a tangent, as the different sides of the building on view will have horizontal planes that extend to different vanishing points. In this example, both vanishing points are out of the picture; the moat façade, diminishing sharply, has a vanishing point close by, but the front elevation with the bridge is viewed at a less oblique angle and has a vanishing point that is further out, far to the left of the picture area.

This side of the building is viewed from only a slight angle and so the horizontal lines recede only very gradually towards the vanishing points; the vanishing points themselves are far outside the picture area.

This side of the building recedes into the distance; the horizontal lines recede much more steeply, but the vanishing points are still outside the picture area.

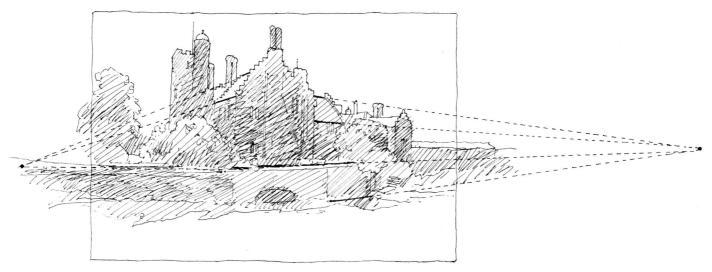

Sketch plotting the vanishing points

The sketch above shows the horizontal planes extended to the vanishing points, which are not visible within the image itself. The greater the angle at which a plane is turned from the vertical, the further out the vanishing point will be. Only horizontal planes angled relatively close to vertical are likely to have vanishing points within the picture space.

Different vanishing points on each side of the subject

To make the drawing shown below, the artist selected a viewpoint that enabled her to see two sides of the building, as this creates a much more dynamic and interesting image than a flat façade viewed square on. Note how the line of the roof, which is above eye level, appears to slope downwards on each side, while the wall, which is below eye level, seems to slope upwards – just as in the examples for single-point perspective on the preceding pages. The difference here is that each side disappears to a different vanishing point (see the sketch above).

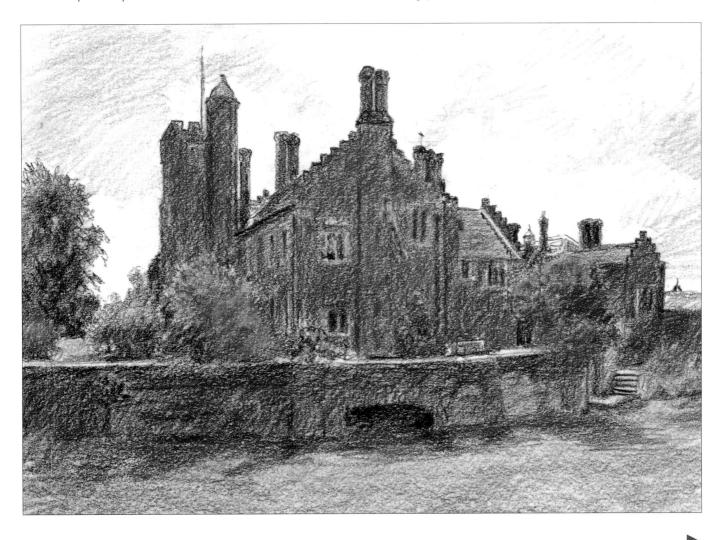

Multiple vanishing points

Multi-point perspective is also used when not all the horizontal elements in view could have their planes extended to the same single vanishing point. In architectural drawings, this may occur if there are several structures built at various different angles to the picture plane. If one large structure – for example, a country house – has wings or outbuildings added at disparate angles to the main building, the planes are also extendible to multiple vanishing points.

However, it is very easy to get so caught up in the technicalities of perspective that you lose sight of your

drawing as a whole. Although you could choose to plot every single horizontal line to its notional vanishing point, the chances are that you would produce a very tight, laboured drawing as a result — it would become a technical exercise rather than a spontaneous response to your subject. Once you've mastered the basic principles of perspective, learn to trust your observational skills. Hold a pencil out in front of you to assess the angle of any horizontal lines as they recede towards their vanishing point. Now measure the distances between different elements of your subject carefully, ignoring any preconceptions that you may have about the relative sizes of things.

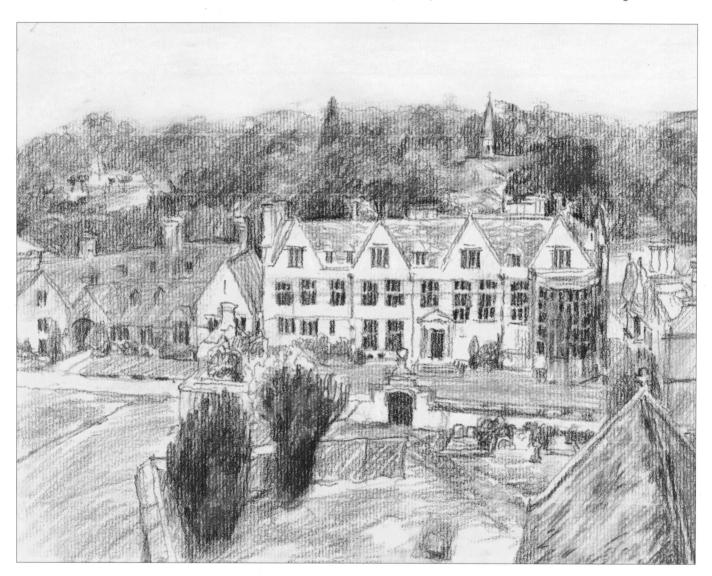

Check - and check again

Careful observation and measuring are the only ways you will be able to tackle a complicated, multi-point perspective subject such as this. We are looking down on the scene; the horizontal lines of the roofs of the foreground buildings appear to converge inwards towards a vanishing point, while

those of the buildings on the far side of the street slope upwards. Note, too, how the inclusion of buildings at different angles to the main house adds interest to the drawing: as well as creating a sense of depth, they also help to lead the viewer's eye towards the main centre of interest.

Foreshortening

You must also gauge the phenomenon of foreshortening in perspective drawing. This term is used to describe the effect of looking along a subject at a tangent, where the length appears shortened but the width is seen as relatively unchanged. Long spans appear much curtailed from the foreshortened viewpoint. For example, viewing a tall person reclining from a vantage point just beyond and above the head shows the long legs and torso taking up little vertical space, while the trunk and limbs are relatively wide. Different degrees of foreshortening may be evident in all the various directions in landscape multi-point perspective work, especially if elements are not on the level.

Foreshortened figure

Figure work often calls for the rendering of foreshortening, as the head, body and limbs are seldom all viewed in profile together, except in simple standing poses. Note that, when seen at a tangent, any element will appear diminished in length or telescoped, while the width is little affected along the span. With extreme foreshortening, you can expect to see some overlaps: for example, a foreshortened head seen from above might show the chin overlapped by the nose. Initially, you may find that it helps to draw a faint box, or cube, in perspective around your subject and plot the vanishing points, just as you would in an architectural drawing.

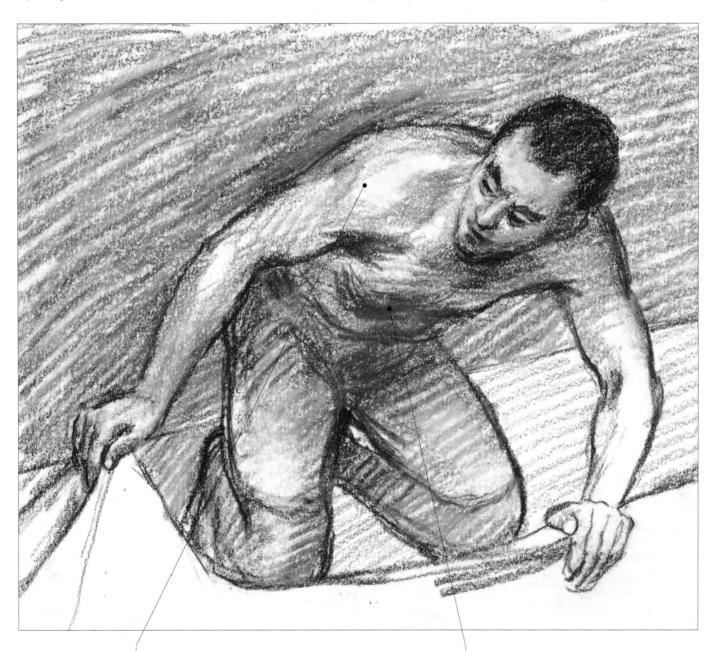

From this viewpoint, the model's right shoulder appears much broader than the left – though they are, of course, the same size.

Viewed from a relatively high eye level, the torso appears shortened in relation to the legs.

Curved forms in perspective

The eye level of the observer determines the distance to the horizon on which the vanishing point or points are fixed. This is the boundary of the visible land or sea, marking the point at which the curvature of the earth turns away so that the continuing surface is no longer seen. Although it is possible to look for some distance on flat land, an even greater vista is possible from a height – for example, a hill or mountain top. From an aeroplane, vast tracts of land are visible before the horizon.

Eye level determines the way circular objects are seen, too. Viewed from above, they appear completely round. When you lower your viewpoint, the same circular form appears to be elliptical, because the span across it is foreshortened, decreasing the apparent length of the diameter in relation to the width. The lower your viewpoint, the narrower the ellipse will appear, but at the extremes the edges are always curvilinear. This is because no round form can have sharp corners, so a curve always defines the width, however tight the turn. Only when the eye level coincides with the profile view of circular objects will the shapes appear flat and show angles at the periphery. Test this for yourself by placing a glass on a table and viewing it from different eye levels - first standing directly overhead so that the top of the glass appears as a complete circle, then sitting down so that the top of the glass appears as an ellipse, and finally crouching on the floor, so that your eyes are level with the top of the glass.

Tall curved forms in real space also appear flatter at eye level and more curved when above or below it. Castles, lighthouses or buildings with circular towers demonstrate this: the base appears flat when viewed at ground level and the upper floors show increasing curvature as they rise above. Knowledge often impairs perception, so guard against the tendency to flatten the bases of smaller circular objects when seen from above, as the base will display more curvature than the top if it is viewed from a higher point.

Circular perspective in a wine glasses

The perspective of circular forms is easier to see if the objects are transparent and the full ellipses, in perspective, are visible. Clear glass is an excellent example and if the glass, dish or vase contains liquid, this too will have to conform to the length and width of ellipse required at that level. Remember that any contents such as flower stems may appear distorted by the curved glass and should be drawn as seen.

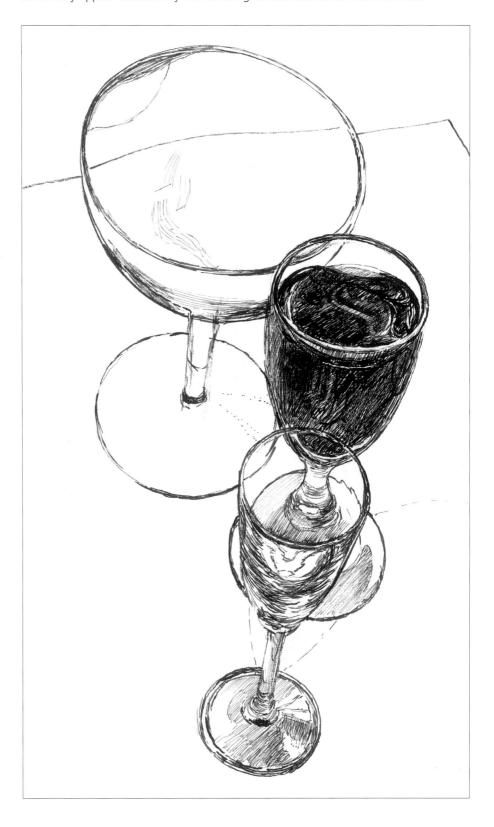

Large circular forms in perspective

Exactly the same principles apply when drawing large circular or cylindrical forms: when they are viewed in perspective, they will appear as ellipses. How flat or round the ellipses are depends on your viewpoint, or eye level – and in a large-scale subject such as the one shown below, the ellipses will vary in different parts of the image because some parts of the subject are above your eye level while others are below it. Here, the round towers of the castle are seen as nearly flat at water level; the bases appear as shallow ellipses. When looking up from the moat, the round tower battlements appear to be most curved, with the stonework between showing gradually increasing curvature as the courses rise. All the rectilinear horizontal planes of the walls and towers in between have vanishing points to the left, far out of the picture space.

- **Tip**: One common mistake that people make when drawing ellipses is to make the ends pointed.
- To avoid this, lightly sketch (or at least imagine) a square enclosing the ellipse.
- Then find the centre of the square by drawing diagonal lines from corner to corner; the two halves of the square will be different measurements, because the parallel lines of the square will converge towards the notional vanishing point.
- Draw a horizontal and a vertical line through the centre of the square in perspective to work out the halfway point along each side of the square.
- Finally, draw the ellipse, using the intersection as a guide to drawing the curve accurately.

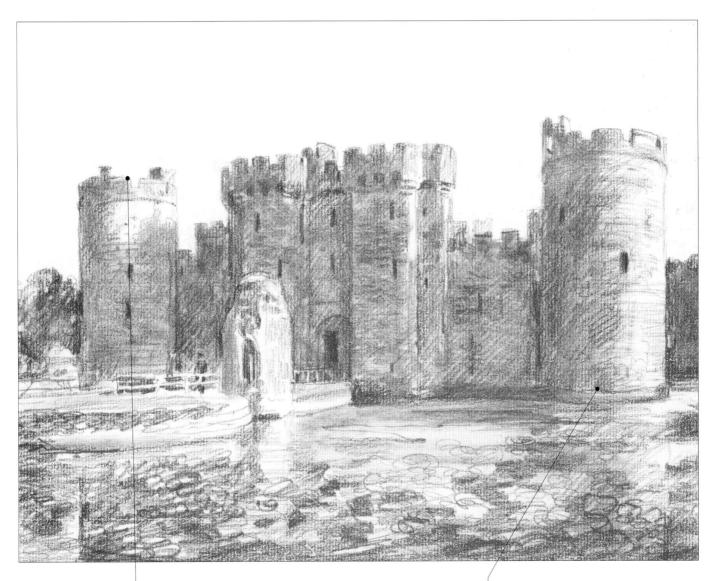

The tops of the towers are above eye level and the curves of the ellipses appear more pronounced.

The bases of the curved towers, which are only slightly below eye level, appear as very shallow ellipses.

Blending with coloured pencils

Unlike pastels, coloured pencils cannot be mixed physically. Each colour keeps its integrity when applied, so the only way to blend or mix colours is to allow this to happen in the eye, optically.

This can be achieved in several ways, and a combination of techniques may be used in the same image. One way is to apply the colour so that it sits in layers, one over the other, rather like a thin watercolour wash or glaze. The reason for applying thin layers is that coloured pencils contain wax, which can build up on the paper surface and make it difficult

to apply further layers. Colour can be applied dark over light or light over dark; the resulting effect and colour mix will differ depending on whether the darker or the lighter colour is applied first.

Colour can also be applied as a series of crosshatched lines – parallel lines that run across one another at an angle. Where the colour comes into contact with the support, it remains bright; where it crosses another colour, the two mix optically. Colours can also be scribbled loosely on to the support, in an action that mixes the first two techniques.

Depth of colour is achieved by increasing the density of the marks – by making them closer together or increasing the amount of pressure on the pencil.

Finally, coloured pencil marks can be made to mix and blend together optically on the support by adopting a technique used by the Pointillists, whereby colour is applied as tiny individual dots. It is the proximity and density of these marks that gives the depth and quality of the colour. This technique is time-consuming and is best used on relatively small drawings.

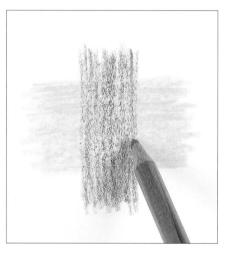

Dark over lightA layer of blue applied over yellow results in a dark green.

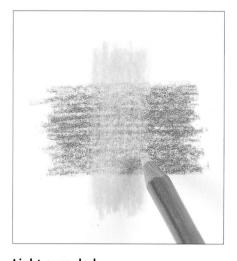

Light over darkA layer of yellow applied over the same blue results in a light green.

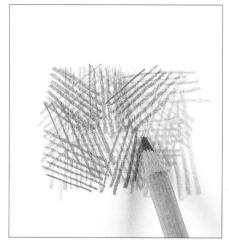

Crosshatched lines in two colours Red lines crosshatched over yellow mix optically to make orange.

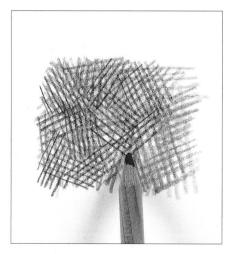

Crosshatched lines in three colours Add blue and the overall effect is that the swatch appears brown – yet all the applied colours have kept their individual integrity.

Loose scribbles
Colours can also be mixed optically by loosely scribbling one over another.
Here, red is applied over green to make a brown.

Rich optical blends
As each colour retains its integrity when blended in this way, the result is likely to look much more lively than an application of a single colour.

Practice exercise

To practise blending coloured pencils, choose a simple subject that contains a limited range of colours. Here, the artist selected a red and green apple – a good subject to begin with, as the colour and surface texture are naturally uneven, so you need not be as precise as you would when drawing a very smooth, evenly coloured surface.

Spend plenty of time looking at your subject to work out where one colour shifts into another. Above all, apply the colour loosely and lightly so that underlying colours can show through, creating lively and interesting optical mixes. To build up the necessary depth of colour you will need to apply a number of thin, light layers – a slow process, but one that merits the effort.

Materials

- Heavyweight smooth drawing paper
- 2B pencil
- Coloured pencils: zinc yellow, bright green, pale vermilion, deep vermilion, deep cadmium yellow, raw umber, Vandyke brown, olive green

The subject

The greens in this apple range from a very yellowy green on the right-hand side to quite a bright mid-toned green in the centre. Similarly, the reds range from a delicate blush to a rich red at the top and side.

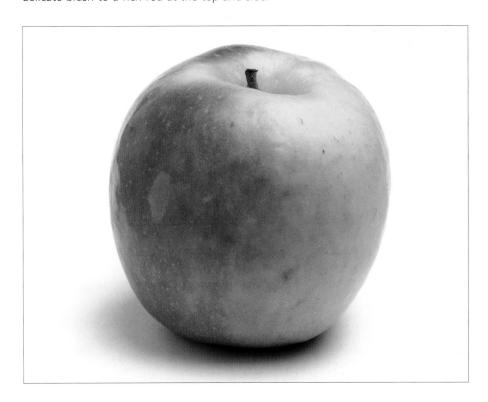

1 Using a 2B pencil, outline the shape of the apple, remembering that it is a rounded form. Put in the stalk, observing the angle. The stalk forms a central axis that runs all the way through to the base of the apple; if you bear this in mind you will find it easier to get the shape at the base right. Also put in the recessed area around the stalk.

2 Lightly fill in the whole of the apple, using a zinc yellow pencil. This colour will stand for even the brightest highlights; leaving the paper white for the highlights would look too stark. Apply a bright green over all the areas that will be green in the final image. Use light strokes that follow the form of the subject.

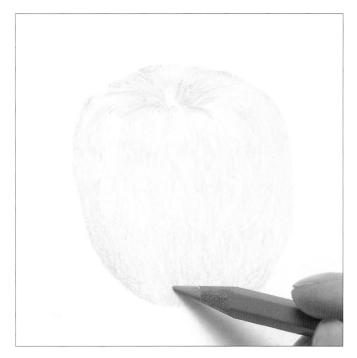

3 Using a pale vermilion pencil, lightly put in the first reds on the apple. Note that the apple itself is not completely smooth in texture or even in tone, so apply the colour unevenly, allowing some of the underlying yellow and green that you applied in Step 2 to show through. Again, make sure your pencil strokes follow the form of the apple.

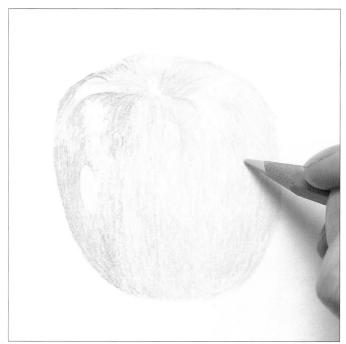

4 Working around the very brightest highlights, strengthen the reds by applying deep vermilion, noting how the colour combines optically with the underlying zinc yellow to make an orangey red. Now look for the more yellow areas of green on the apple, and go over them with a deep cadmium yellow pencil.

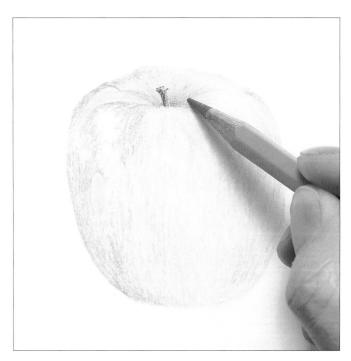

5 Now colour in the stalk. It is a darker brown on one side than the other, because of the way the light hits it, so alternate between raw umber for the paler brown areas and Vandyke brown for the darker areas. Using an olive green pencil, lightly draw the indentations in the skin around the stalk. As a result of this shading, the apple is beginning to develop some form and depth.

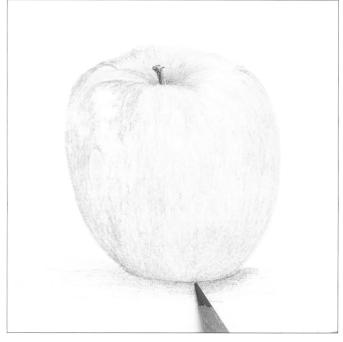

6 Still using the olive green pencil, put in the darker areas of green on the apple and the shadow underneath it. The shadow helps to anchor the subject on a surface: it no longer looks as if it is floating in mid-air. Some colours from the apple (red and brown, in particular) are reflected in the shadow, so put these colours in very lightly to give some visual continuity to the picture.

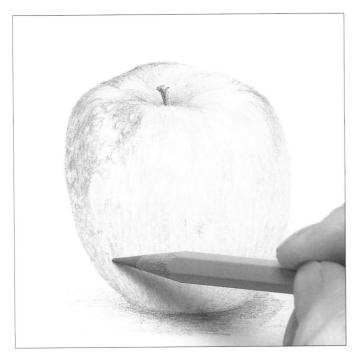

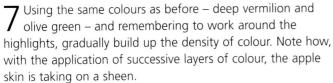

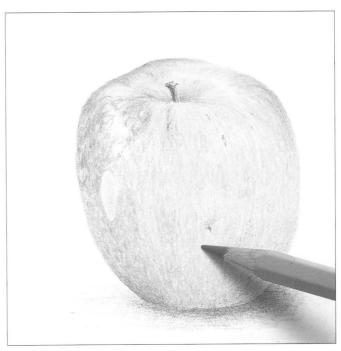

Working slowly and methodically, continue building up the density of colour, using the same colours as before and light pencil strokes. Finally, use the olive green pencil to put in the dark, mottled patches on the apple skin and add some texture to the drawing.

The finished drawing

At first glance, this is a deceptively simple drawing – but note how effectively the artist has built up the layers of colour to create a beautifully textured surface in which the colours combine optically into a seamless whole. Coloured pencils are the perfect medium for conveying the mottled coloration of the apple skin: they can be used to cover both broad areas and precise points of detail.

The contrast between the very bright highlight and the dark red of the apple skin helps to make the fruit look shiny.

Thin strokes of the pencil allow the underlying colours to remain visible.

Blending with soft pastels and oil pastels

Soft pastels can be blended both physically and optically; more often than not, a combination of techniques is used in a drawing. The dusty, loose pigment that is left on the support after a mark has been made can be manipulated in a number of ways. The handiest tool for blending colours is your finger - but make sure that your hands are clean and free from grease. Your little finger is usually the coolest and driest part of the hand and hence the best one to use. For larger areas such as skies, you can use the side of your hand in a light, circular motion. A rag or piece of kitchen paper can be used in the same way and a cotton bud (cotton swab) is ideal for intricate areas. However, the tool intended for the job is the torchon. Made from rolled or compacted paper pulp, it is used to move the pigment

around the surface of the support. Torchons get dirty very quickly, but you can clean them by rubbing them on fine abrasive paper.

Harder pastels and chalks can be used in the same way, but they can be sharpened to a point so you can mix colours by using scribbled and hatched marks, as with coloured pencils. Both hard and soft pastels can also be blended by lightly glazing one colour over another. Success depends on how much loose powder is already on the support; you may find it advantageous to apply a thin layer of fixative between applications of pastel, to prevent the colours from smudging.

Oil pastels can be blended with the finger, but the results are not as satisfactory as with soft pastels. They can also be mixed simply by working one colour into another. Take care not to build

up too much pastel on the support, as this can prevent you from applying more. Oil pastel drawings made on oil paper or on a paper prepared using gesso can be blended together using a solvent such as white spirit (paint thinner) or turpentine.

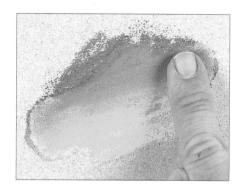

Finger blendingThe easiest and most convenient way to blend soft pastels is to use your finger.

Blending with a torchon

A torchon can be used to blend soft pastels in the same way. As it has a pointed end, it is good for small areas.

Pointillist approach

Optical mixes can be achieved by applying dots of pure colour, in the same way as the Pointillist painters.

Applying a glaze

Soft pastels can also be mixed by applying a thin glaze (covering) of another colour.

Crosshatching

Hard pastels can be sharpened to a point and used to create mixes by scribbling in layers and hatched or crosshatched lines.

Layering

Oil pastels can also be mixed and blended by working in scribbled layers.

Blending with a solvent

Oil pastels can be blended by working into the applied colour with a spirit solvent such as white spirit (paint thinner) or turpentine.

Practice exercise: Seascape in soft pastels

Drawing skies and clouds is the perfect way to practise blending techniques in a powdery medium such as soft pastel or charcoal: because the precise shapes are not important, you can practise moving the pigment around on the paper without having to worry about getting the detail exactly right.

This exercise is also a good lesson in restraint! If you overblend the colours in the water and clog up the tooth of the paper with pigment, you will end up with a flat, lifeless image. Similarly,

if you overblend the colours on the rocks you will end up with a muddy-looking mess with no discernible tonal variation. The rocks will appear as silhouettes against the brightness of the sea.

Materials

- Pastel paper
- · Grey pastel pencil
- Soft pastels: mid-grey, dark grey, black, reddish brown, mid-green, pale grey, mid-blue, dark brown, fawn, pale yellow

The scene

This is a moody and atmospheric seascape, with storm clouds billowing overhead and sunlight glinting on the water. Although the colour palette appears limited at first glance, there are a number of different tones within the clouds and rocks and these need to be blended smoothly. The artist used two reference photos for this exercise – one for the detail of the foreground rocks and one for the stormy sky and sunlight sparkling on the water.

1 Using a grey pastel pencil, outline the headland and foreground rocks. The artist has changed the composition to make it more dynamic: in the photo, the horizon line is in the centre – but here it is positioned lower down.

2 Using the side of a mid-grey soft pastel, block in the darkest tones in the sky and blend with your finger. Allow some areas to remain darker than others, as there is a lot of tonal variation in the clouds.

Apply a darker grey pastel for the clouds immediately overhead. (The difference in tone helps to convey a sense of distance, as colours tend to look paler towards the horizon.) Build up the very darkest areas of cloud with more dark grey and black, blending the marks with your fingers as before. Remember to leave some gaps for the white of the paper to show through, to create the impression of sunlight peeping out from behind the clouds.

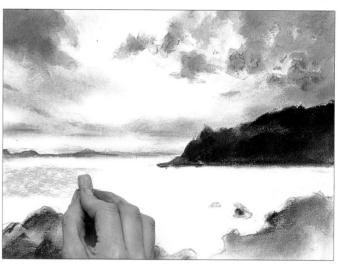

A Block in the headland with a dark reddish brown and smooth out the pastel marks with your fingers. Use the same reddish brown for the foreground rocks, then overlay the brown in both areas with a mid-green, blending the colours only partially with your fingers so that both colours remain visible. Gently stroke the side of a pale grey pastel across the water area, leaving the central, most brightly lit, section untouched.

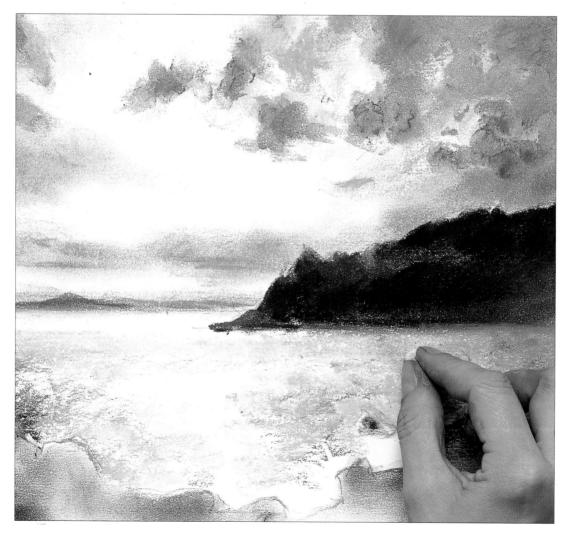

■ Darken the water **)** by overlaying touches of a dusky mid-blue, green and black. Do not overblend the marks or apply them too heavily: it's important to see some differences in colour within the water and to allow some of the white of the paper to show through to create the impression of light sparkling on the water.

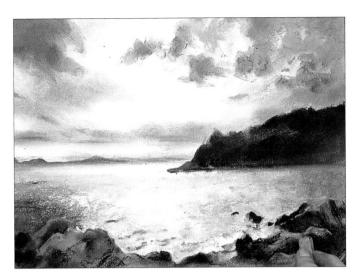

6 Now build up more of the texture on the foreground rocks. Loosely block in the darkest areas (the shaded sides of the rocks) in reddish brown, then overlay dark brown and green and blend the colours slightly with your fingers. For the lighter sides of the rocks, use greys and fawns. Immediately the rocks begin to look three-dimensional.

The finished drawing

This drawing uses a number of blending techniques. In the sky, softly blended marks create the impression of swirling clouds. The texture and form of the rocks in the foreground are achieved by overlaying several colours, allowing each one to retain its integrity, and adding a few linear marks as the

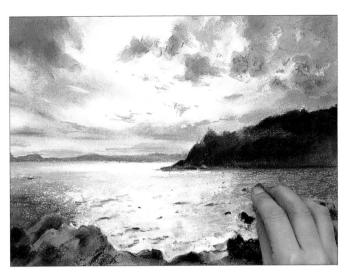

Zightly draw a pale yellow line along the horizon and add touches of yellow in the sky to warm it up, blending the marks with your fingertips or a clean rag. Using the tip of a mid-grey pastel, put tiny dashes and dots for colour into the sea to create the impression of wavelets and a sense of movement in the water.

finishing touch. Our overall impression of the water is that it is a dark blue-grey, but on closer inspection we can see a number of different colours and tones within it – optical mixes that enliven the scene and also imply the movement of the waves in the sea.

Although little detail is discernible in the distant headland, some tonal variation is essential in order to prevent it from appearing as a solid silhouette. The tonal variations also tell us something about the form of the land.

It is important not to overblend the marks in the water or to obliterate the white of the paper completely.

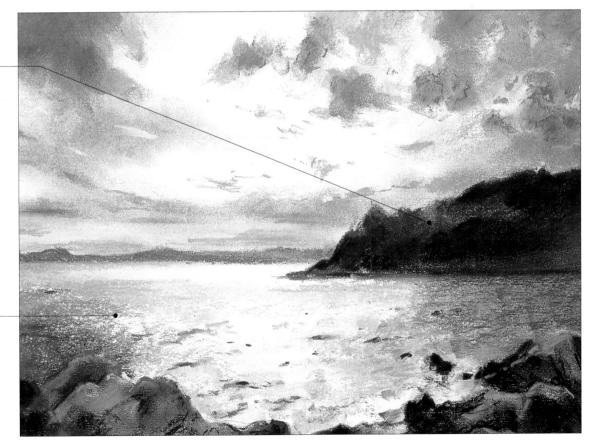

Practice exercise: Still life in oil pastels

In this exercise, you can practise two very different ways of blending oil pastels – by using your fingers and also by working colours on top of one another so that they blend optically. In the final stage of the drawing, you will also see how to brush a tiny amount of solvent over oil pastel to dilute the colour and create a smooth texture.

The range of oil pastel colours is not as extensive as that for soft pastels, so you can't always achieve realistic-looking colours. Instead of worrying about it, go for a more decorative approach.

Materials

- Oil painting paper
- Oil pastels: pale grey, yellow, dark green, pink, purple, dark red, orange, bright green, pale green, blue, dark blue
- Craft (utility) knife
- Flat brush
- Turpentine or white spirit (paint thinner)
- Kitchen paper

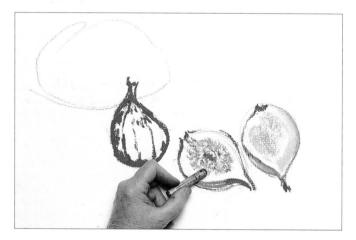

1 Using a pale grey oil pastel, outline all the fruit, then outline the figs in yellow and green and lightly block in the inside of the cut fig in pink. Put in the purple markings on the skin of the uncut fig. Apply a little yellow around the edge of the fleshy interior of the cut fig. Dot dark red on to the cut surface and add some orange around the edge.

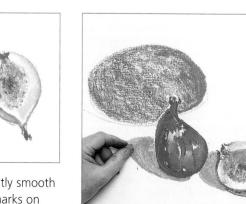

The set-up

This simple still life of a mango and two figs contains lively colours and interesting textures. The fruits were arranged on a white background and lit so as to cast shadows on the table, which stops them looking as if they're floating in thin air.

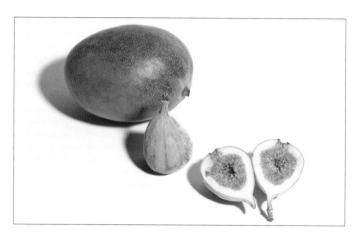

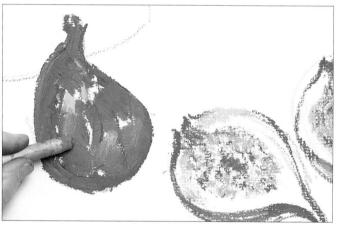

2 Apply very bright green oil pastel over the purple of the uncut fig and a little yellow in the brightest parts, making sure you leave a few small areas of white paper for the highlights. Then add some pale green over the top, again reserving the highlights. Note how the colours blend together optically, creating a very lively looking mix.

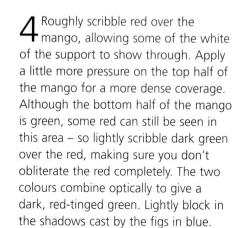

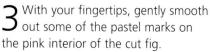

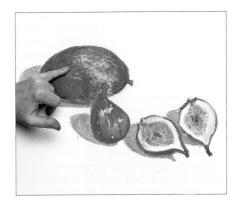

5 Apply more dark green over the bottom half of the mango, still allowing some of the red pastel and the white of the paper to show through. Add a little dark blue, as some of the red is so dark that it is almost purple, and a little pink over the centre, to soften the transition from green to red. Blend the marks just a little; it is easy to end up with a flat, muddy mix that retains none of the liveliness of individual colours.

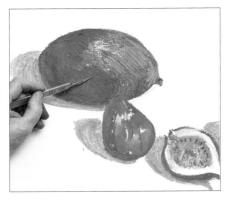

6 Using the tip of a craft knife or other sharp-tipped object, lightly scratch a series of thin, parallel lines over the mango to create the soft bloom on the surface of the fruit. 'Draw' the lines close together and angle the knife so that you don't dig into the paper and damage the surface. Apply tiny dots and dashes of red oil pastel around the interior of the cut fig to create the rich, red seeds and add more texture.

Dip a flat brush in turpentine or white spirit, dab off any excess on kitchen paper and carefully pull down a little yellow oil pastel from around the edge of the cut figs to reduce the starkness of the paper.

Tip: Keep dabbing the brush on kitchen paper or a rag between strokes to avoid dirtying the support.

The finished drawing

This is a simple still-life exercise, but it demonstrates the different effects that can be created using oil-pastel blending techniques. The optical colour mixes on the mango are much

livelier than a flat application of a single, physically mixed colour could ever be. Finger blending and scratching into the oil pastel with a knife create lovely textures.

A combination of finger blending and optical colour mixing enlivens the surface of the mango.

Solvent dilutes the colour, while the brush marks create a smooth texture for the soft flesh of the fruit.

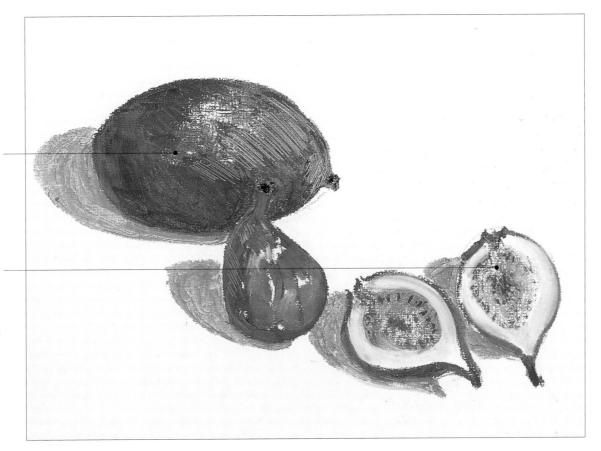

Blending with water-soluble pencils

Water-soluble coloured pencils behave in exactly the same way as non-soluble coloured pencils and you can use exactly the same techniques of scribbling, hatching and glazing to blend them. The difference is that when you apply water, the dry pigment breaks down and becomes liquid colour – and then behaves in the same way as watercolour paint.

Applications of colours look clean and bright when applied dry, because each applied colour, in effect, remains separate from those around it. Once water is applied and the colours mix together physically, however, the colour may look dull and dirty. The answer is to keep to simple, two-colour mixes.

Remember that once water has been applied and the colours blended, the image can be dried and further applications of dry colour applied over the top. These, in turn, can be worked into and the process repeated several times, just as when painting in watercolour.

An alternative way of applying watersoluble pencils is to apply a wash of clean water to the support and work into it, taking care not to damage the surface by digging the sharp pencil tips into the softened paper fibres.

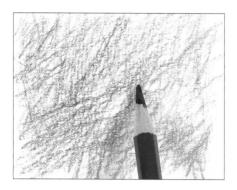

Applying water-soluble pencilsWater-soluble pencils are applied in exactly the same way as conventional coloured pencils.

Applying water

When water is applied, the coloured pencil work is converted into watercolour.

Muddy mixes

Beware of combining too many colours, as the mixes can look dirty when water is applied.

Varying the tone

To lighten the tone, add more water or lift off wet pigment with the brush or a piece of kitchen paper.

Practice exercise: Bananas

This exercise allows you to use watersoluble pencils in a linear fashion to draw the shape and facets of the bananas, and as a kind of watercolour, by brushing with clean water.

When you set up an exercise like this at home, the key is to keep it simple! If you choose a complicated group of objects with too many colours, the chances are that when you add water to the pencil work, your washes will look muddy.

Materials

- HP watercolour paper
- Water-soluble pencils: yellow ochre, mid-green, burnt sienna, bright yellow, dark brown, violet
- Brush
- Clean water

The set-up

A plain background provides a contrast in colour without detracting from the main subject. Here, a light was placed to one side of the bananas so that some facets were in shadow. The difference in tone between the light and the dark facets is what will make the subject look three-dimensional.

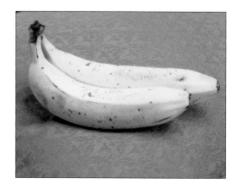

1 Lightly sketch the bananas using a yellow ochre water-soluble pencil. (This is the mid-toned yellow of the bananas. The hard line will disappear when you brush over clean water in the later stages of the drawing.) Indicate the different facets of the fruit as well as the outline shape.

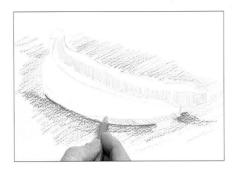

 Block in the background with a mid-green water-soluble pencil, applying more pressure for the shaded area under the fruit. Apply yellow ochre to the shaded facets of the bananas.

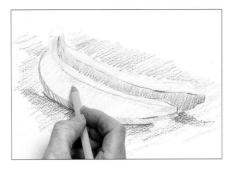

2 Loosely hatch the darkest parts of The bananas with burnt sienna, allowing some of the underlying colour to show through. Apply bright yellow loosely all over the bananas.

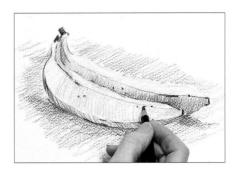

4 Draw the stems with a dark brown water-soluble pencil and dot in some dark marks on the bananas. Apply more burnt sienna over the most deeply shaded facets.

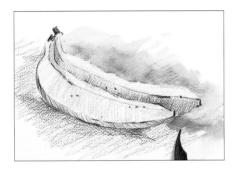

☐ Dip a brush in clean water and carefully brush over the background, making sure you do not brush any of the background colour on to the bananas. You can move the pigment around on the support in exactly the same way as you can with watercolour paint. Leave to dry. (If you wish, you can use a hairdryer to speed up the drying process.)

* Clean your brush and brush over the bananas. Take care not to apply too much water, or it may spread on to the background.

Tip: If you want to vary the tone in

parts, dab off pigment with a piece

of kitchen paper.

7 While the paper is still wet, take a dark brown pencil and darken the stem. Also dot in some stronger marks on the bananas. The pencil marks will blur a little on the damp paper, so you end up with a soft spread of colour rather than a sharp point. Add a touch of violet in the most deeply shaded area and put in more of the shadow cast by the bananas in the same colour.

The finished drawing

This simple little study demonstrates the potential of water-soluble pencils very well by combining linear marks with simple washes. By limiting the number of colours used, the artist has kept the colours bold and bright.

Linear detail is still visible. If you accidentally destroy linear marks that you want to keep, draw them again once the water has dried.

Washing over the hatched lines of burnt sienna with water has softened the marks to create a darker tone on the shaded facets.

The background is a soft wash of colour, against which the bananas stand out clearly.

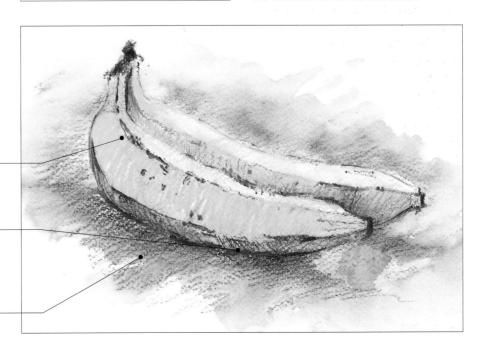

Brush drawing

Although we tend to associate brushes with painting techniques, they are extremely versatile drawing tools and are capable of producing tremendously expressive lines.

Soft-haired brushes, of the kind used in watercolour painting, are best for this kind of technique. You can also use Chinese brushes, which are designed for calligraphy. They hold a lot of ink or paint, so you don't need to keep stopping to reload the brush, and the tip comes to a fine point so you can vary the width of the line with ease. The hairs of both Chinese and watercolour brushes are very flexible, making it easy to alter the direction of the line you are making; with a brush, you can round corners smoothly in situations where you might falter with a pen or pencil. Experiment with different types of brush and compare the marks that you can create with each one.

Also experiment with the way you hold the brush. If you hold it on or near the ferrule (the metal part that holds the hairs of the brush in place), you will have a great deal of control. This is great if you are making small, short marks, but longer marks may look tight and laboured, as you control the brush primarily with your fingers, which can move only a limited distance. Holding the brush about halfway down the shaft, or even near the end, allows you to make longer, sweeping strokes from your wrist, so you get a much more flowing line. Similarly, try the side of the brush as well as the tip to see what difference that makes.

You can use either ink or paint with this technique. Waterproof ink can be brushed over once it is dry without the risk of it spreading, but the blurring that occurs with water-soluble ink is an attractive effect in its own right; the choice is yours. If you want to use paint, watercolour, gouache or acrylic (all of which are water-soluble) are all suitable.

You can make brush drawings on virtually any support – paper, board or canvas. If you use ordinary drawing paper, opt for a reasonably heavy type so that the wet ink or paint does not soak through and tear the support. However, unlike watercolour painting, there is no need to pre-stretch the support; you are not flooding it with water or paint, so it is not likely to cockle.

One key drawback of brush drawing is that if you make a mistake in paint or ink, it is much harder to erase than a pencil mark. For this reason, it is always a good idea to map out the main lines of your subject first by making a very light pencil underdrawing – at least until you feel confident enough of your drawing skills.

Short marks and dotsHold the brush perpendicular to the paper and touch the tip on to the surface.

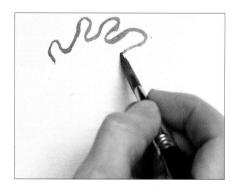

Short, undulating linesFor greater control, hold the brush on the ferrule; you can change the direction of the brush simply by moving your fingers slightly.

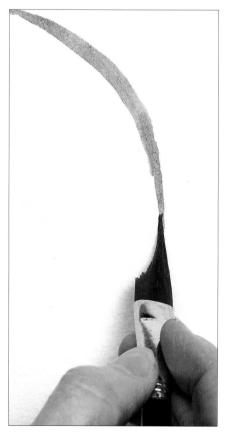

Thin curves

For thin, relatively short curves, hold the brush on the ferrule so that you can control it easily and apply only the tip to the support.

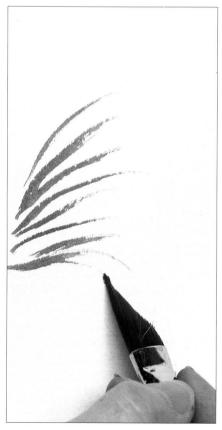

Short lines that tail off

Lift the brush up from the support as you near the end of the stroke so that only the tip is touching when you reach the final part of your mark.

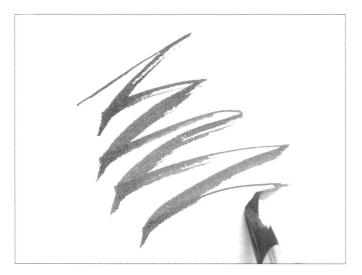

Lines of varying widths

Use the side of the brush, pressing the hairs on to the support, to make broad strokes; on the upstroke, lift the brush so that only the tip is touching the support to create a thinner line.

Broad strokes

Hold the brush further up the handle, press the full length of the hairs on to the support and use a sweeping motion to pull the brush across the paper.

Practice exercise: Poppies

These flowers are a wonderful subject for brush drawings. When the flower heads are fully open they are floppy, with slightly frilled edges, which you can depict by means of flowing, expressive lines. The stalks, too, twist and turn in interesting ways. They are covered in tiny hairs and, while it is neither possible nor desirable to draw them all, you can convey the texture with a few swift flicks of the brush. The leaves give you the opportunity to make spiky, linear marks of different thicknesses, using the tip of the brush for the veins.

Materials

- Pre-stretched watercolour paper
- 2B pencil
- Watercolour paints: cadmium red, olive green, ivory black, ultramarine blue
- Brush

The set-up

Fresh poppies wilt quickly so, for this exercise, the artist used artificial poppies. She decided to simplify the composition to include just one full bloom, one bud and a few leaves. This gives an uncluttered picture that allows us to appreciate the shapes of the flowers to the full.

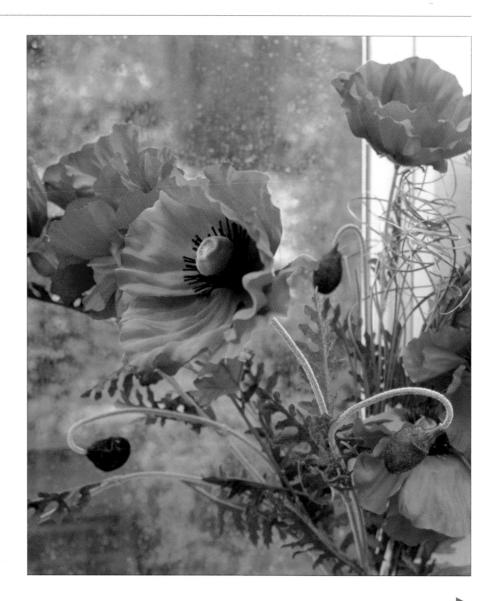

Lightly sketch your subject in pencil. If you're confident, you could omit this stage and put in the initial lines of the flowerhead using a brush and paint – but to begin with, it's best to ensure you get the basic structure right. Use a medium-size brush and cadmium red watercolour paint to outline the shape.

2 Put in the main striations in the petals of this large flower. The flowerhead consists of several overlapping layers of petals. Indicate the petal overlaps by giving them thicker brushstrokes, using the side of the brush to achieve this effect rather than resorting to painting them using just the tip.

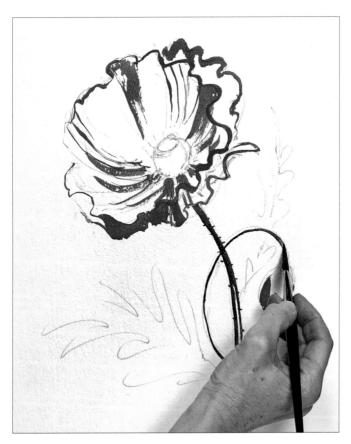

Rinse your brush in clean water. Using olive green paint and the tip of the brush, draw the stem. Flick the tip of the brush sideways to draw the tiny hairs along the stem. To get a lighter shade of green, add a little more water.

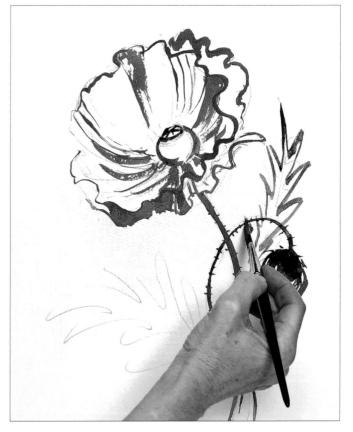

4 Block in the olive green of the poppy bud and the centre of the main bloom. Outline the leaves. Draw the stalk of the bud in the same way as in Step 3, again adding a few little hairs along its length to create a different texture.

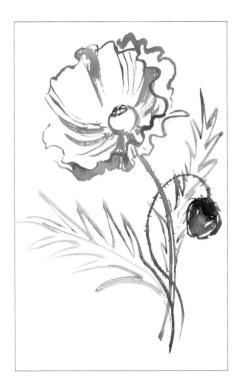

5 Complete the outline of the leaves and put in the vein that runs down the centre of the largest leaf.

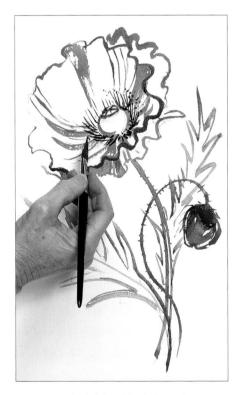

6 Mix a dark blue-black from ivory black and ultramarine blue (black on its own tends to look 'dead'). Using the tip of the brush, draw the tiny stamens around the centre of the large flower. Load the brush sparingly so you don't flood the paper.

The finished drawing

This is an energetic brush drawing, full of flowing lines that capture the characteristics of the flower extremely well. The artist has used a wide range of brushstrokes, from delicate flicks of the brush for the hairs on the stems to lines of varying width for the spiky leaves and broad marks for the overlapping petals. Even though much of the paper is left white, she has put in just enough detail to convey the shapes and textures.

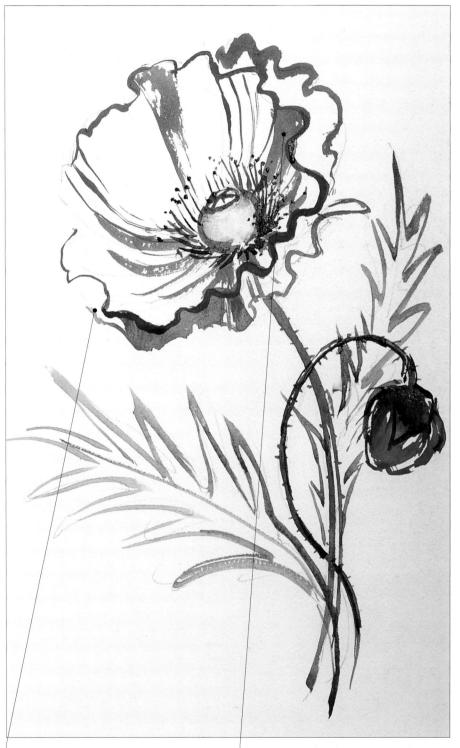

Thin, flowing lines made using the tip of the brush convey the attractively frilled edges of the petals.

Broader strokes, made using the side of the brush, imply the way petals overlap one another in this large flower.

Line and wash

The term used to describe a combination of pen-and-ink work and watercolour or ink washes is line and wash. Pen and ink is often employed for subjects that contain a lot of linear detail, such as buildings and architectural details, but can result in a somewhat mechanical feel particularly if you are using a technical drawing pen, which does not allow you to vary the width of the line. The advantage of using line and wash is that by brushing clean water over watersoluble ink to dissolve the lines, or applying a wash of dilute ink or watercolour paint over lines drawn in permanent ink, you can soften the overall effect and create areas of tone that contrast well with the detailed pen work.

The key is not to make your work too detailed. The best line-and-wash drawings allow the viewer to infer much of what is being shown. Be selective and pick out the essential details of your subject – a good discipline, whatever medium you are working in.

Think, too, about the quality of line that you want to create and choose your pen accordingly. Technical drawing pens give a very even, regular line, but can be too rigid and regular for some people. Dip pens give a lovely quality of line, and you can vary the width by turning the pen over and drawing with the flat back of the nib — but you do have to keep stopping to re-load the pen with ink and some find this disruptive to their drawing. Many artists prefer so-called sketching pens, which are loaded with a cartridge that holds a considerable amount of ink.

Finally you need to choose whether to use waterproof or water-soluble ink. Once it has dried waterproof ink, as the name implies, will not run if a wash is applied on top of it. With water-soluble ink, on the other hand, you can brush over the marks with clean water to dissolve them and create an area of tone. You can, of course, use both types of ink in the same picture, provided you plan things in advance and work out which areas you want to blend with water and in which ones you want to retain the detail of the line work.

Brushing over waterproof ink

When you brush over dry waterproof ink with clean water, the linear work remains and the quality of the drawing is not altered in any way.

Scribble a few lines using permanent ink, and allow to dry.

2 Brush over the lines with clean water. The lines will remain.

Brushing over water-soluble ink

When you brush over dry water-soluble ink with clean water, the linear work is dissolved to create an area of tone.

1 Start by scribbling a few lines using water-soluble ink, and allow these lines to dry.

2 Brush over the lines with clean water. The water will dissolve the ink, creating an area of pale tone.

Creating dark tone

To create a darker area of tone, simply apply more ink to the paper by making the lines closer together.

1 Hatch, or crosshatch, a series of lines close together, using water-soluble ink.

2 Brush over the lines with clean water. As before, the water will dissolve the ink – but because the lines were drawn close together, more ink has been applied to the paper and the resulting area of tone will be darker.

Practice exercise: Combining permanent and water-soluble inks in the same drawing

This exercise uses crisp, permanent ink work for the details of the wrought-iron gate and some areas of foliage, and water-soluble ink brushed over with clean water to create areas of tone in the foliage and brickwork.

Take plenty of time over your initial pencil sketch to make sure you've got the elaborate scrollwork details and proportions right. Only then should you start going over the lines in pen and ink. Much of the right-hand side of the gate will be obscured by foliage in your final drawing, but a good underdrawing will ensure you've got the structure right and the gate symmetrical.

Materials

- Heavy drawing paper
- HB pencil
- Technical drawing pen loaded with permanent black ink
- Sketching pen loaded with watersoluble black ink
- Brush

The scene

This late nineteenth-century wrought-iron gateway is partially covered by greenery and it is hard to see the intricate detail. In a drawing, however, you can subdue certain elements and emphasize those on which you want to focus attention.

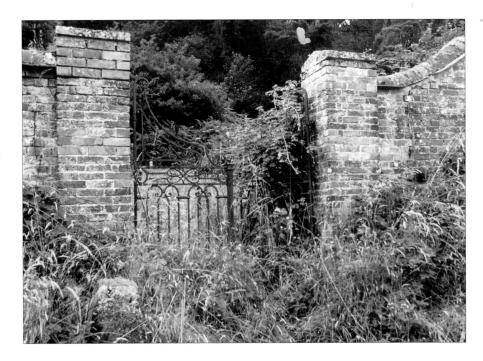

1 Using an HB pencil, lightly sketch the scene, using single lines for the bars of the gate to be sure you've got the placement and proportions right. Once you've got this stage right, you can go over the gate in pencil again, putting in a double line for each bar. A loose impression of the foliage shapes is sufficient. Similarly, you don't need to draw every individual brick.

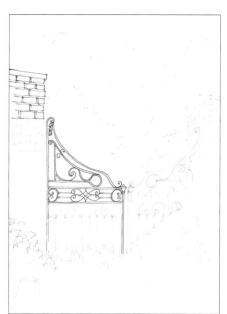

2 Using permanent black ink, go over those areas of the gate in which you want to retain detail. Draw the bricks in permanent ink, too.

Tip: Work from top to bottom or from left to right to avoid smudging what you're already done.

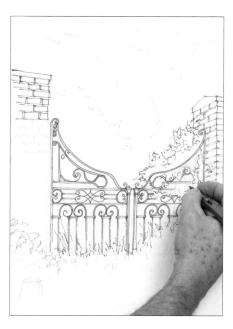

3 continue working on the gateway, using permanent black ink. Loosely scribble in the top of the grasses below the gate in permanent ink. Switch to water-soluble ink and begin outlining the tendrils of foliage that hang over the gate. Working on the foliage will make it clear which parts of the gate are obscured by leaves and do not need to be drawn in permanent ink.

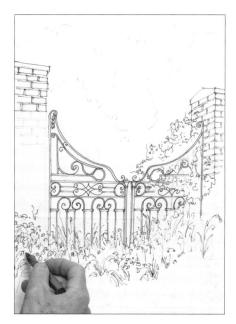

4 Continue working on the foliage and the vegetation in front of the gateway, using both permanent and water-soluble inks for the foreground area. Try to capture the general pattern of growth, without putting in every detail.

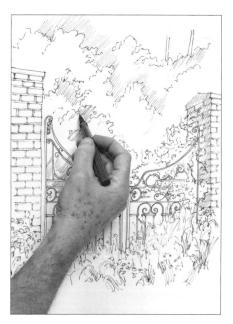

5 Using water-soluble ink, lightly shade the left-hand side of the right-hand brick pier to show which direction the light is coming from. Hatch the darkest areas of foliage in the background trees so that you begin to develop some form in this area.

6 Hatch the darkest areas of the foreground vegetation, in front of the gate, in the same way. Erase any remaining pencil marks. Using permanent black ink, fill in the scrollwork on the wrought-iron gate so that it stands out from the background.

Thanks to the loose hatching done in the previous stages, the drawing is now starting to look three-dimensional. Stand back and assess whether any areas need to be darkened with more hatching before you go on to the next stage.

Load a paintbrush with clean water and lightly and rapidly brush over the foliage area behind the gate, leaving some areas untouched. The water-soluble ink will dissolve, creating areas of tone that contrast well with the linear work on the gate.

Pepeat the process on the foreground vegetation and gently pull some of the wet ink (across) on to the brickwork to make it look less stark. If necessary, go back over some of the foliage in pen and ink (once dry) to create more texture and density of tone.

The finished drawing

If this drawing had been made using pen and ink alone, the result would have been very harsh. It would also have been hard to differentiate between the different parts of the image, as the foliage and gate are very similar in tone. Brushing clean water over carefully selected areas of water-soluble ink has softened the image, allowing the gate – which is the main focus of interest in the drawing – to stand out clearly. Although black ink was used throughout, the artist has created a number of tones by varying the density of the hatching and by working back over the washes to add more detail.

The background foliage to this gateway is suggested, rather than drawn in detail.

Permanent black ink was used for the gate; even if water was accidentally brushed on to these areas, the lines would remain.

The foreground vegetation was darkened and given more texture by drawing back over the wash.

Masking

Although it is usually associated with painting and the application of fluid colour, masking can be put to excellent use with dry drawing materials. One of the traditional uses of masking in painting is to prevent paint from getting on to an area where it is not wanted. Masks can be used in this way in drawing, too.

The main application of masking in drawing, however, is to create an interesting edge that might be difficult to achieve by other means. The technique can be used with all drawing materials.

There are a number of materials that can be used as masks. Perhaps the most common and well known is masking tape, which can be cut or torn to the required shape. Take care when removing it from the paper, however, as it can easily tear soft-surfaced papers. It is also difficult to apply masking tape over areas that have been worked on using powdery materials, such as pastel or charcoal. Masking film (frisket paper) is another option.

Paper and card (stock) can easily be cut or torn to shape. Thick watercolour paper makes an excellent mask, as it tears in interesting ways. For straight edges, nothing is as quick as scribbling colour or tone up to the edge of a thick piece of card, although you can also use the edge of a ruler in the same way.

Paper and card masks can either be held in place or fixed with masking tape. But even if you tape the mask in place, it is a good idea to take the added precaution of holding it down while you are working so that there is no chance of it slipping out of position.

Masking to create straight lines

There are many occasions when you need to apply colour or tone right up to the edge of a straight-sided subject – when blocking in a sky behind a building, for example. Holding a mask along the straight edge allows you to work right up to the edge without risking accidentally applying colour over the area you want to protect.

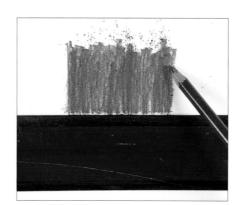

Hold the edge of a ruler or a cut piece of card along the straight edge and apply colour or tone. It doesn't matter if you scribble over the mask as the mask is there to protect the area underneath.

When the ruler is removed, the straight edge along the base of the area of colour is evident. It would be difficult to achieve such a crisp edge working freehand, and you can work much more freely with this technique.

Using a mask to create a shaped edge

Masks can also be cut or torn to create interestingly shaped edges.

Practice exercise: Using torn and cut masks

This is a fun exercise in using masks made from torn and cut paper to make a sketch of broccoli stems and florets. You don't need to be terribly precise about the shape of the mask as the florets have irregular edges.

Materials

- Smooth drawing paper
- Scrap paper
- Thin charcoal stick
- Scissors

The set-up

Place a stalk of broccoli on a white tablecloth or a piece of white paper and adjust the leaves and stem until you have an attractive composition. This particular variety of purple sprouting broccoli has attractive leaves with serrated edges, which add another texture to the drawing. Position a small table lamp to one side to create shadows that you can incorporate into the composition.

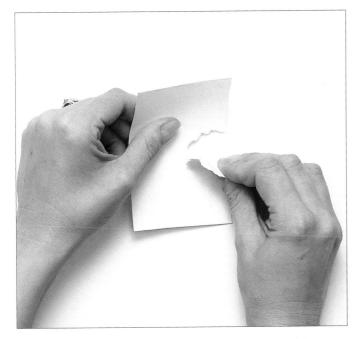

Take a piece of scrap watercolour paper and roughly tear a jagged, curved shape for the broccoli florets. Watercolour paper is fairly heavy and tearing it produces lovely, irregular edges that are perfect for this kind of subject.

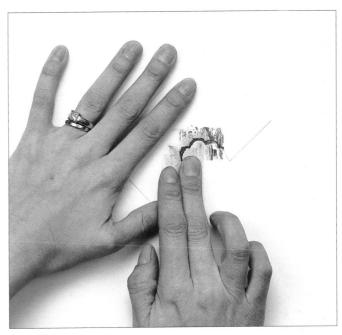

2 Hold the mask firmly in position on the paper and, using a thin stick of charcoal, make a series of short, vertical marks around the torn edge. With the mask still in place, blend the marks with your fingers.

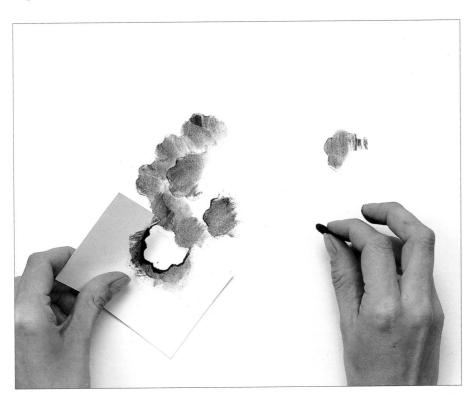

Remove the mask. You will see that you have made a semi-circular shape with irregular edges. Move the mask further along the paper and create a second floret in the same way. Continue working around the broccoli, creating a series of overlapping florets, until you have completed the head.

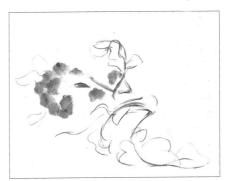

4 Outline the leaves and stem. Put in the leaf veins with long, flowing strokes and blend with your fingertips.

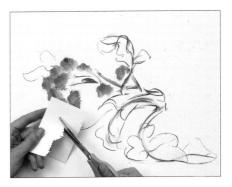

5 The edges of the leaves are slightly jagged – unlike the more rounded forms of the broccoli florets. Cut a second mask for the leaves, keeping the cuts random in shape and size.

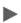

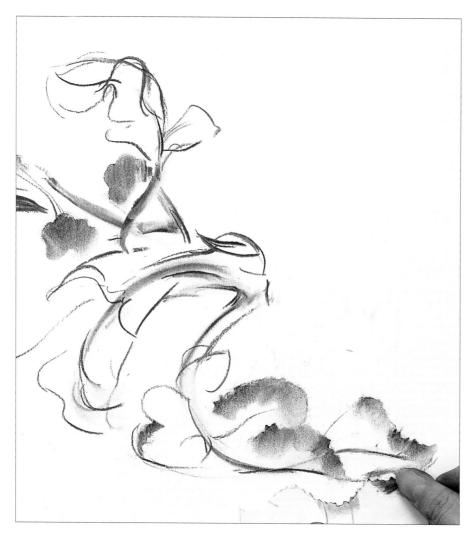

6 Place the leaf mask in position and apply charcoal up to and over the edge, as in Step 2. Use different sections of the mask, or turn it upside down, to create the shapes you want, lifting and replacing it further along the stem as you work around the leaves.

Tip: Use a kneaded eraser to clean the mask at regular intervals, so that you don't accidentally transfer smudges to the drawing.

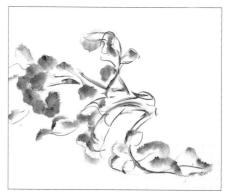

Zontinue working around the stem of broccoli until all the leaves are in place. Note how the leaves flop and twist over one another and the stalks.

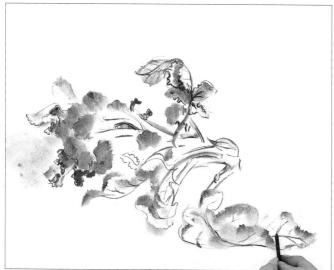

Use the side of the charcoal to block in more tone on the leaves where necessary, gently blending the marks with your fingers as before. With confident, flowing strokes, using the tip of the charcoal stick, put in the most prominent veins on the leaves. These strong, linear marks contrast nicely with the blended tone on both the leaves and the florets. The drawing is really taking shape now.

Overy lightly stroke charcoal on to the background, following the shape of the cast shadows, and blend with your fingers. The shadows need to be much softer and lighter in tone than the broccoli, so you will not need to apply much charcoal; you may even find that your fingers are already covered in so much charcoal that you can use them as a drawing tool in their own right!

10 Place the broccoli floret mask that you used in Steps 2 and 3 in position again and go back over the shapes, making a series of small dots and dashes to create some texture. Don't blend the marks this time.

This is a very lively drawing, full of vitality and movement. Masks have been used to create random, irregular edges on

1 1 Add more detailing and texture to the broccoli florets by making a series of short, hook-shaped marks with the tip of the charcoal. These dark marks stand out well against the smoothly blended charcoal base.

both the florets and the leaves, complementing the flowing, calligraphic-style lines of the stems and veins.

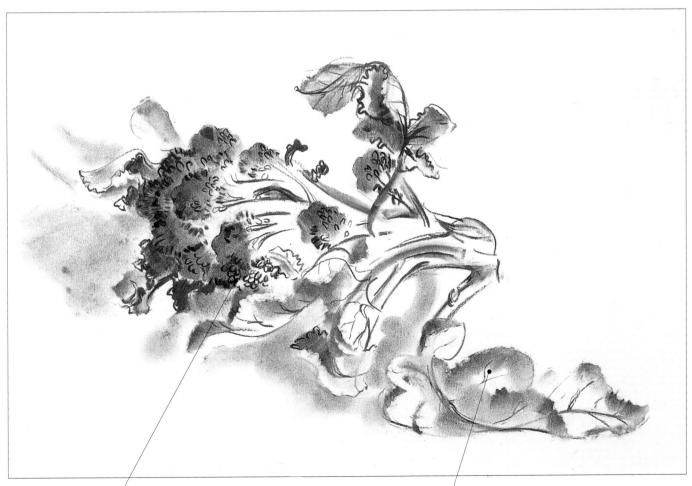

Short, linear marks on top of the smudged charcoal create the texture of the broccoli florets.

The mask was turned upside down to create leaves of different shapes.

Eraser drawing

Erasers can be used for far more than simply making corrections: they are also a powerful drawing tool in their own right. The difference is that they are used to remove marks, rather than to add them. The technique works best with high-contrast subjects that contain both very dark and very light tones. It is also a good way of picking out highlights as by using the tip of the eraser or a cut edge, you can wipe out very precise marks.

Erasers can be used with graphite, coloured pencils, charcoal, pastel and chalks, as well as with all types of pigmented artists' pencils. Different erasers produce different marks, and some perform less well than others with certain materials. Kneaded erasers can be moulded to shape, making it possible to work into tight, precise areas. However, they become dirty very quickly and are of limited use with pastel or charcoal. Vinyl and plastic erasers are harder and do not

become dirty so quickly. They can be used with softer drawing materials without becoming completely clogged and unusable. Use only clear or white erasers, as coloured erasers can leave a mark on white paper. When an eraser does get dirty, you can clean it by rubbing it on a scrap piece of paper or by cutting away the dirty edges with a craft (utility) knife. Use the sharp edges of a cut eraser to draw sharp, precise lines and the blunter edge for working into wider areas of colour or tone. If the eraser picks up colour or pigment as you use it, take care not to transfer that colour on to an area where it is not wanted.

You can also use masking techniques with erasers, by working up to the edge of a piece of card (stock) to create a precise edge or by working over torn paper to create a more random edge. As an alternative to commercially available erasers, try rolling a piece of soft, white bread into a ball and using it to clean up white areas of paper or lighten an area of tone.

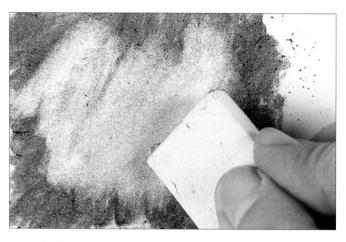

Kneaded eraser

Graphite can easily be removed using a kneaded eraser, but loose, pigmented materials such as charcoal and pastel will clog the eraser very quickly, making it unusable.

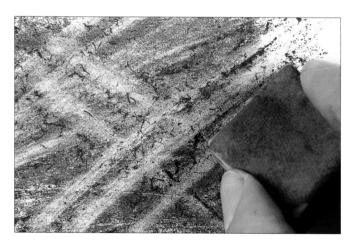

Using the cut edge of an eraser

To wipe out precise marks or shapes, use the sharp edge of a cut eraser. Use only white or clear erasers to ensure that you don't leave any scuff marks.

Shaping erasers

Erasers of all kinds can be cut into pieces with a craft (utility) knife and discarded when they are too small or dirty. Kneaded erasers can be pulled to a point for working in small areas.

Using a mask with an eraser

To create precise edges, place a straight-edged mask over the edge of the area to be erased, hold it down firmly, and erase right up to the edge.

Practice exercise: Still life

In this exercise, erasers are used to wipe out highlights and enhance the threedimensional feel of the drawing. The papery skin of the garlic is full of tiny crinkles, the ridges of which catch the light. If you were to draw these individually, the chances are that your drawing would look somewhat laboured and tight – but using the cut edge of an eraser allows you to wipe out a line that is slightly uneven and much more sympathetic to the subject. For broader highlight areas, the flat side of the eraser is used. As with all textural techniques, your eraser strokes should follow the form of the object.

As a variation on this exercise, cover the paper with graphite or charcoal and use an eraser as a drawing tool.

Materials

- Smooth drawing paper
- 9B graphite stick
- Plastic and kneaded erasers

1 Using a 9B graphite stick, outline the bulbs of garlic.

2 Put in the internal lines in the garlic skin, following the contours of the individual cloves beneath. Using loose hatching marks, apply some tone.

The set-up

In this simple set-up, a bulb of garlic and a twisted section of peeled garlic skin were arranged on a dark marble background, creating a composition that contains strong contrasts between very dark and very light areas. The stalks were carefully angled to create a diagonal line that makes a dynamic composition.

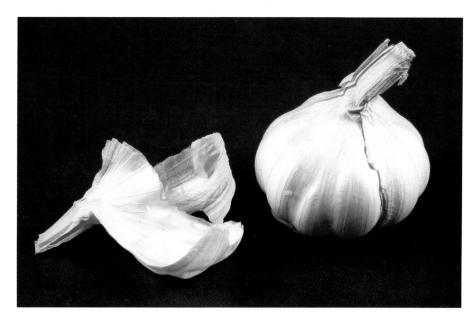

Continue adding tone to the garlic, using loose hatching marks. Note how the form of the garlic immediately becomes more evident, as the more deeply shaded areas reveal both the contours of the individual cloves and the ridges in the papery outer covering.

4 Applying reasonably heavy pressure to the graphite stick, scribble in the dark background. Work carefully up to the edge of the garlic, redefining its shape as you work.

5 Using the sharp, cut edge of a plastic eraser, wipe out fine lines on the garlic skin. These thin, bright lines help to show the crinkled, papery texture of the skin.

6 Using the flat side of a kneaded eraser, wipe out larger areas of tone to reveal the highlights on the garlic. If you accidentally wipe off too much, just hatch over the affected area again.

This simple still life relies for its impact on the contrast between very dark and very light areas. Using an eraser to wipe out the highlights has resulted in loose, natural-looking lines that capture the crinkled texture of the garlic skin, and has produced a more integrated drawing than could be achieved by positive applications of pigment alone.

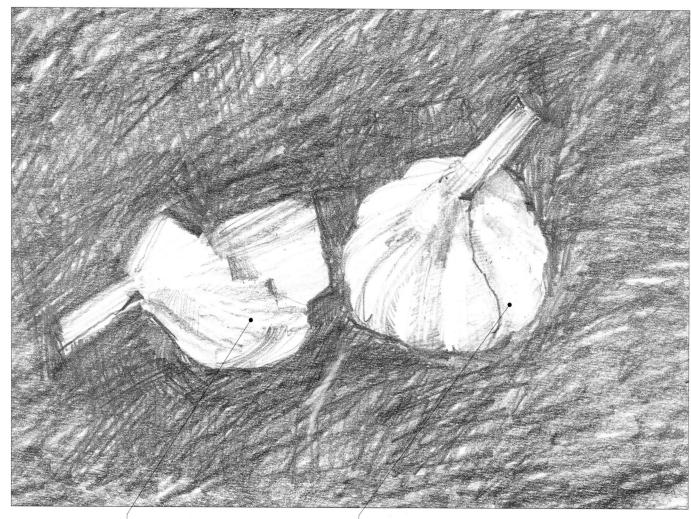

The sharp, cut edge of the eraser creates fine highlight lines.

Broader areas are wiped out using the flat side of the eraser.

Sgraffito

The technique of using a sharp implement to expose an underlying layer of paint or pigment, or the support, is called Sgraffito. Although it is perhaps more commonly associated with painting, it can also be used with certain drawing materials as a way of creating texture.

Sgraffito is especially successful with thick applications of soft pastel or oil pastel. You can use any sharp implement to make the marks – a craft (utility) knife, scissor blades, paper clips, even your fingernails. If you want to scratch through just one layer of soft pastel to

reveal the layer beneath, fix the lower layer before you apply the top one.

Work confidently and quickly to create a sense of energy in your work – but remember to scratch through the pastel rather than cut into it, otherwise you risk damaging the support.

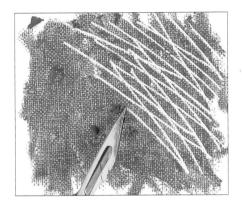

Scratching into oil pastel

Oil pastel on oil sketching paper can be removed or scratched into using a sharp craft (utility) knife.

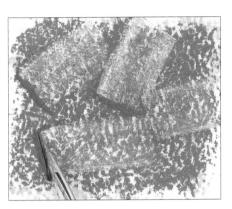

Scratching into soft pastel

To remove one layer of soft pastel to reveal the layer underneath, use the flat of the blade.

Scratching into charcoal

Any soft, pigmented drawing material can be scratched into. Here, linear sgraffito work is made into charcoal.

Practice exercise: Woodland scene

Woodland thickets, which are full of tangled undergrowth and spiky twigs and branches, are the ideal subject for practising the sgraffito technique, as you can scratch off pigment to reveal underlying colours and create thin, energetic lines that capture the profusion of growth to perfection.

For this exercise, the artist chose a dark brown oil pastel paper the same colour as the branches of the trees and scratched off pigment to reveal the colour of the support. She also used sgraffito in other areas, scratching off only the top layer of pigment to create interesting textural effects and colours in the foliage and grasses.

Materials

- Dark-toned oil pastel paper
- Oil pastels: dark brown, black, violet, dark green, white, bright yellow, dark blue, reddish brown
- Scraperboard tool

The scene

Here the artist selected elements from two photographs. Don't follow your reference photo too closely: try instead to capture the spirit of the scene and the direction of growth. Woodland scenes can look very jumbled and confusing, so always make sure there is a strong centre of interest. Here, it is provided by the large, solid tree trunk towards the left of the image, which the artist positioned 'on the third'.

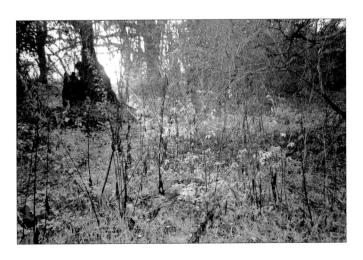

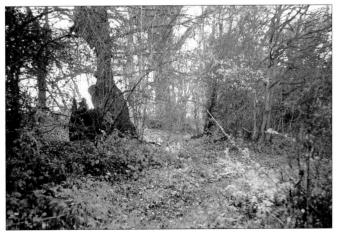

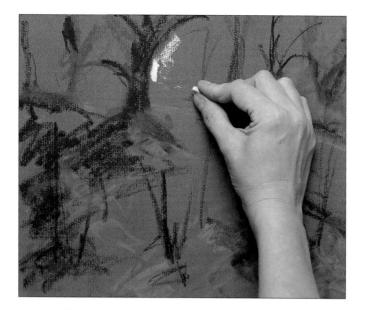

Roughly indicate the main trunks and branches, using dark brown, black and violet oil pastels. Scribble in the main patches of foliage in dark green. Using the side of a white oil pastel, block in the light areas of sky between the trees.

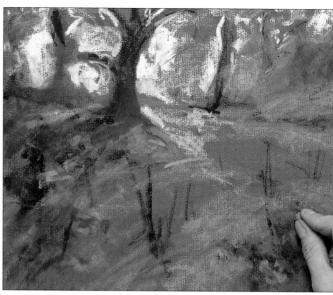

2 Put in the areas of very yellow foliage with a bright yellow oil pastel. Now look for the shadows: using a dark blue oil pastel, scribble in the deepest shadow areas on the ground and the shaded sides of the tree trunks.

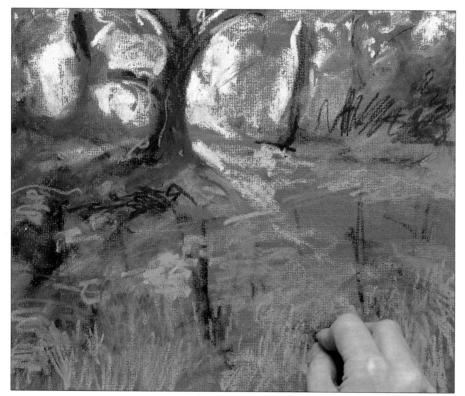

to help bring this area forwards in the scene and create some sense of recession.

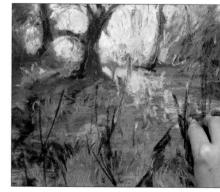

4 Using a scraperboard tool, scratch off thin lines across the white of the sky to reveal the underlying paper colour and create the thin and spindly branches of the background trees.

5 Add the sunlit, dead foliage in reddish brown, and patches of sunlight in yellow.

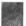

Tip: You may find that it helps to half-close your eyes so that you see the scene as patches of colour rather than as individual stems and grasses.

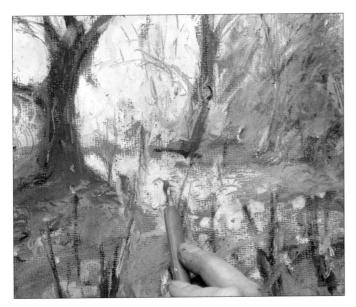

6 Continue building up the colours in the foreground, then use the scraperboard tool to scratch across this area and create the impression of tall, thin grasses and stalks. Scratch horizontally and vertically, following the direction in which the grasses grow, and also use a scribbling motion to create a tangle of intertwined leaves and twigs.

The finished drawing

Here, the artist has used the sgraffito technique to create a lively, highly textured drawing that captures the tangled undergrowth and the spindly branches to perfection.

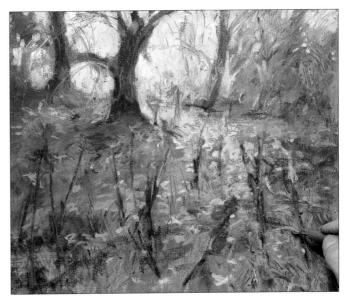

Continue scraping into the foreground, using a variety of marks – dots, dashes, vertical strokes and zig-zag lines – to suggest the patterns of growth in the vegetation. For dark areas of shadow, you can use the scraperboard tool to smear thick applications of oil pastel across the support as well as to remove it.

There is a good balance between marks made with the oil pastels, such as the larger trunks and branches, and sgraffito marks for things such as the spiky grasses and twisted stems.

Lines scratched into the white of the sky reveal the underlying support and create the impression of thin branches.

Energetic, vertical scratches reveal the colour of the underlying layer of oil pastel and create movement.

Drawing smooth textures

Smooth surfaces are often hard and include things such as glass and plastic, metal, polished wood, stone and marble. Hard, smooth surfaces are often reflective. They may not always be mirrorlike, but they do reflect any directional light source and pick up and reflect colours from objects that are near by.

Hard surfaces can cover extremely complex shaped objects such as a corkscrew or a coffee percolator. On curved surfaces, reflections are often distorted, which can make the smooth surface appear far more complex than it really is. Some smooth-surfaced objects such as polished marble also have a surface pattern, and in order

to reproduce the true quality of the object, this will need to be rendered, too.

Work on a paper that is appropriate to the subject. Hard, smooth objects have a clean, smooth outline with clearly defined crisp edges, and a smooth, hot-pressed or NOT paper will help you to achieve the correct feel.

Practice exercise: Smooth leather ball

In this exercise, the smooth surface of the ball is created by building up layers of soft pastel and blending out the marks with either your fingertips or a torchon.

Although it is not highly reflective, the leather ball is shiny enough to reflect the light source. Such highlights can be drawn by leaving the paper white or, when working in a soft, powdery medium such as the pastel pencils used here, by wiping off pigment with a kneaded eraser.

Materials

- Smooth drawing paper
- Pastel pencils: ochre, red, dark brown
- Torchon (optional)
- Kneaded eraser

The subject

A ball was lit from the front to create a bright highlight near the top. Note the gradual change in tone from the front of the ball to the back, as the light falls off.

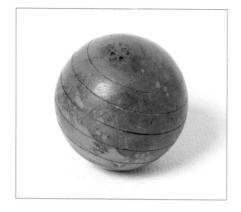

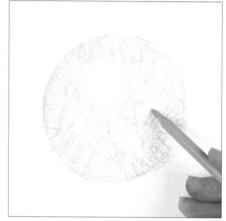

Apply the lightest colour first. Using an ochre pastel pencil, scribble on the pigment using multi-directional strokes. Leave the white paper to represent any highlights.

2 Blend the pastel pencil work, using your finger or a paper torchon. The pigment does not have to be completely smooth; blend it just enough to soften any of the scribbled lines that show too clearly.

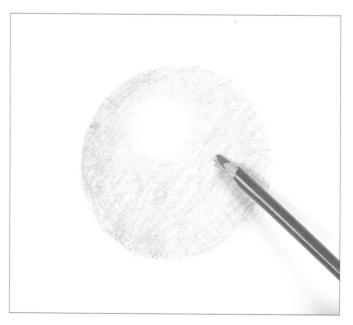

 $\bf 3$ Repeat the process, using a red pastel pencil; the two colours blend together to create the rich, reddish-brown of the leather. Apply lighter strokes around the highlights and blend the colour slightly using your finger or a torchon.

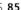

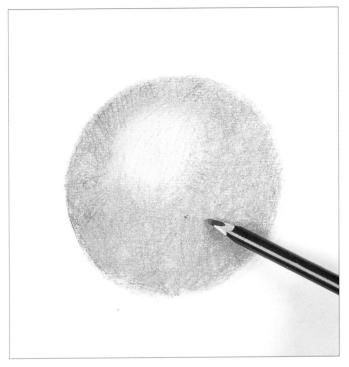

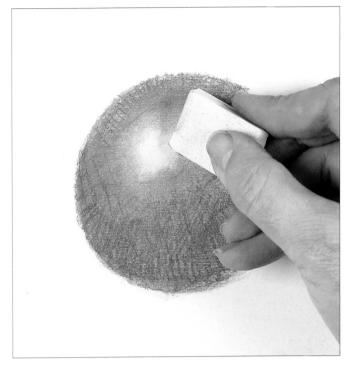

4 If the highlight is too light, lightly scribble over the area using the ochre and red pencils. Next apply the dark brown pastel pencil over everything except the highlight.

5 Once you have applied all the colour, you can re-establish the highlight if necessary by gently lifting off pigment with a kneaded eraser.

Leather reflects the light that is positioned above it, so careful observation of the size and shape of the highlight is the key to the success of this drawing. Working on a smooth paper also helps, as does blending the pastel marks to obtain a smooth, even coverage.

The bright highlight tells us that the subject is both smooth and shiny.

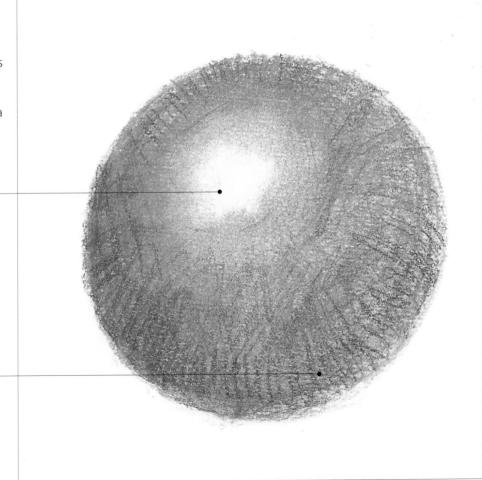

The smooth surface texture of the ball is conveyed by means of light, blended pastel strokes.

Practice exercise: Stainless steel olive oil pourer

When you're drawing metal, remember that it is a hard substance and that the edges of metal objects, even if they are irregular in shape, are very clearly defined. Metal is a highly reflective surface, although the reflections may be distorted. Metal tends to pick up very bright highlights, which will help you to convey the form of the object you are drawing. Finally, remember that all metals (and metals such as silver and stainless steel in particular) take much of their colour from objects that are reflected in the surface - so look at the surroundings as well as at the objects that you are drawing.

Materials

- Smooth drawing paper
- Charcoal pencil
- White chalk

The subject

In terms of its shape, this is a relatively simple subject to draw – but in order for it to look convincing you will need to recreate the smooth, shiny texture.

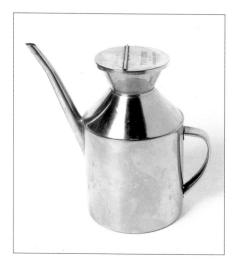

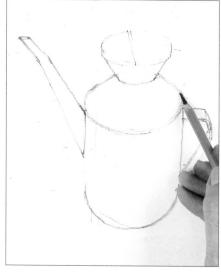

1 You need to establish first the shape of the olive oil pourer using relatively light lines made with a charcoal pencil.

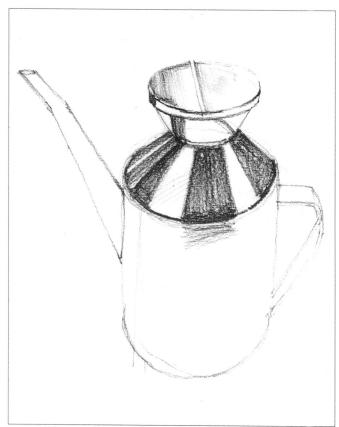

2 Establish the darkest reflections using heavy charcoal work, carefully working around any areas that reflect the light. Note how putting in these dark reflections immediately tells us something about the shape of the object: although the lid of the oil pourer is not faceted, the shapes of the reflections do help to imply that it is gently curved.

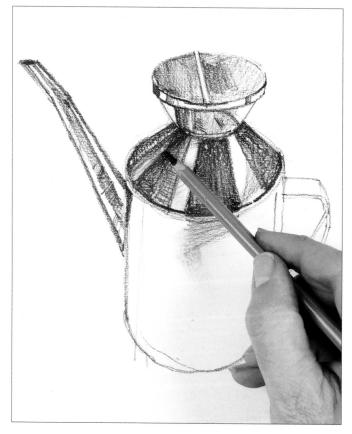

3 Consolidate the darkest areas, such as the very dark lip of the lid and the inside of the tip of the spout, and begin to draw in the mid-tones using light pencil work. Blend the pencil marks by using your fingertips or a paper torchon: the surface of the oil pourer is smooth, so try to ensure that no pencil marks are visible.

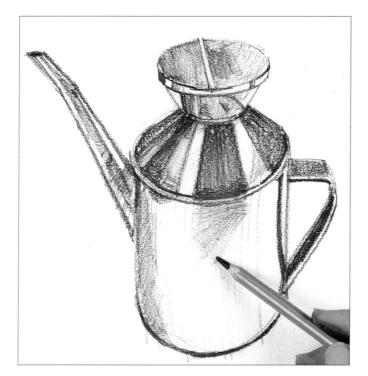

4 Continue to work the mid- and light tones on the cylindrical body of the pourer, using pencil marks that follow the contours of the object.

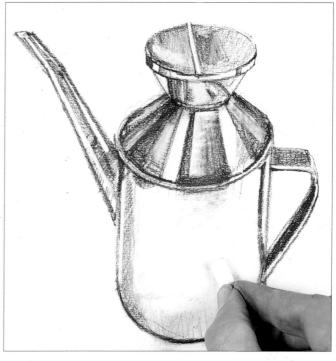

5 In order for the hard, shiny, reflective surface to read correctly, the marks need to be precise and sharp. Use a white chalk to sharpen the highlights.

This metal's smooth and shiny surface is achieved by building up the layers gradually and by observing the shape, position and tone of the highlights carefully.

Note how the edges of the metal object are very clearly and crisply defined.

The light catches the outer edge of the handle, creating a very bright highlight, while the inside of the handle is in deep shadow.

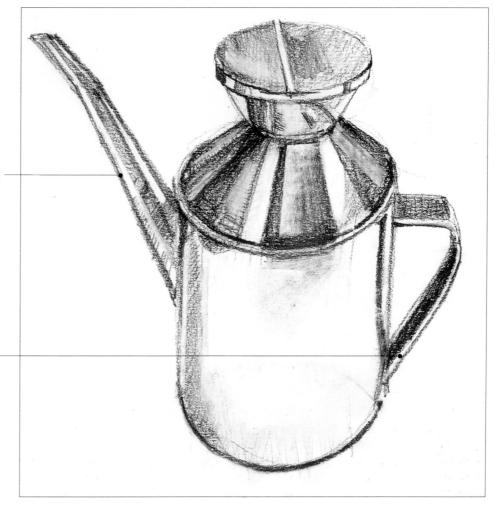

Drawing rough textures

For an artist, rough textures are perhaps the most fun to draw as they allow you to use a whole range of calligraphic and textural marks. The types of rough surface that you will come across include pitted stone and rock, brickwork, weathered wood and bark, certain animal skins such as elephant and rhino, and some types of fabric (hessian, for example).

With a rough-textured subject, working on a surface that has some

texture to it will help the mark-making process – but beware of choosing a support in which the texture is too dominant, as no amount of mark-making will prevent it from showing through.

Many rough textures are repetitive over a large area – but this does not mean that you have to draw in the texture so that it covers the area. You can suggest the texture in places and, if this is done successfully, the viewer will mentally fill in the missing bits. In fact, it can be a mistake to draw in textures too comprehensively as they can easily overpower a drawing and make it appear lifeless.

The degree to which a rough texture shows up depends very much on the quality and direction of the light. In bright light that hits the object at an angle, the texture will appear to be quite pronounced; in flat light, the same texture will appear less evident.

Practice exercise: Weathered driftwood

With a subject such as this, you can explore a wide range of marks to convey the texture – flowing, linear strokes for the main lines of the wood grain, short dots and dashes for little indentations in the surface, and smudged marks for dark areas of tone.

Materials

- Rough watercolour paper
- Charcoal stick

The subject

This piece of weathered driftwood has lots of tiny cracks and crevices within it, as well as a deeper recess in the centre. Lighting it from the left casts a shadow to the right of the wood and also helps to reveal the texture.

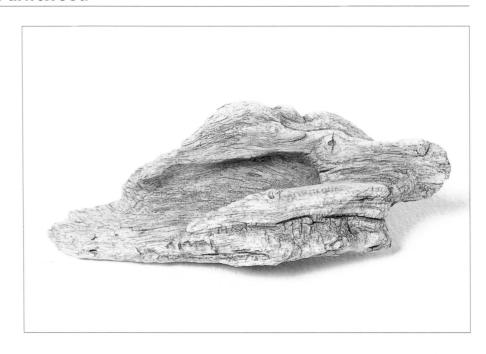

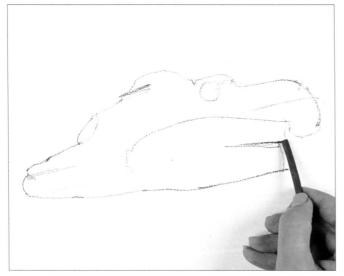

1 Establish the shape of the piece of driftwood using stick charcoal on a sheet of rough watercolour paper. It helps to put in the most obvious cracks as guidelines.

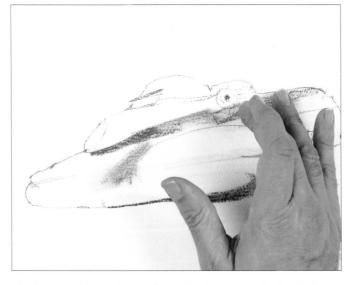

2 Once you have drawn the main shape, put in the darker areas of tone using the side of the stick. Blend the pigment and push it into the paper surface using your finger.

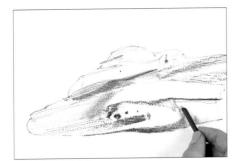

3 Continue building up lines and tones on the driftwood surface. Note how the texture of the paper reads through these marks and helps suggest the pitted, weathered surface.

4 Once you have drawn the main tones and flowing lines of the wood grain, put in the darker areas deep in the splits and holes using heavy pressure and firm, deliberate marks.

5 Complete the sketch with light, flowing texture lines and put in a dark shadow beneath the object, smoothing out the marks with your fingers.

This is a lively drawing in which a combination of confident linear marks and soft blending of the charcoal creates the texture of the wood. Note how the linear marks follow the direction of the wood grain. The cast shadow anchors the piece of wood on the surface and provides an interesting shape in its own right.

Practice exercise: Pitted stone

The stone has very obvious indentations of differing sizes in the surface and this irregularity is something that needs to come across in the drawing. At the same time it is hard and unyielding, so your marks need to convey this. Blend the colours to create the overall background colour and then apply dabs of oil pastel on top for the holes.

Materials

- Oil sketching paper
- Oil pastels: dark brown, ochre, mid-grey
- White spirit (paint thinner)
- Paintbrush

The subject

Note the slightly jagged, irregular outline of the stone – very different from the smooth outline of surfaces such as metal. This is one of the keys to conveying its rough texture.

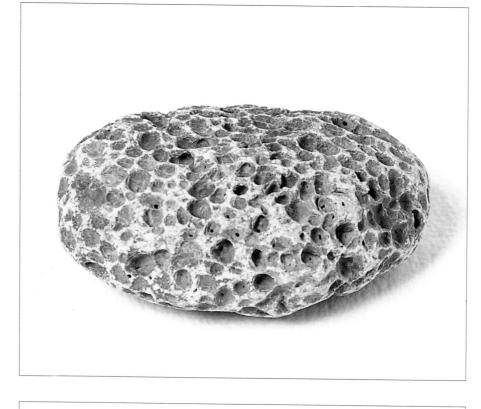

1 Establish the shape of the stone and the position of the pitted marks using a dark brown oil pastel.

2 Build up the colours within the rock using an ochre and a mid-grey pastel. Make loose, directional strokes that follow the contours of the stone.

3 Apply white spirit to dilute the pastel work and distribute it over the image surface, allowing some of the linear work to show through in places.

4 While the surface is still wet, use various colours to re-establish the contours and dark holes on the stone's surface, keeping the work fluid and loose.

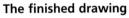

Blending the oil pastel with white spirit enabled the artist to smooth out the tone to create the relatively even coloration

5 Finally, work into areas of the stone that are still smooth, brushing on a little more white spirit to blend the pastel colours together where necessary.

of the stone, while stronger dots of colour on top effectively convey its hard, pitted texture.

Drawing soft textures

Soft textures include skin, animal fur and feathers, and fabrics. These types of texture are often affected by an underlying structure (for example, the skeleton in the case of an animal or bird). Sometimes, they are covered in a pattern or design, and the design or pattern on a surface can tell us about the shape of that object, as the way lines flow or a pattern is distorted indicates the structure that lies underneath.

The texture of soft objects is, more often than not, relatively smooth. Even animal fur and birds' feathers, when viewed from a distance, appear smooth and unruffled.

As with rough textures, when you are drawing fur or feathers it is neither necessary nor advisable to put in every hair and every feather. Skin needs to be treated with care, as any texture is barely noticeable; even in elderly people, where

the inevitable wrinkles can be seen, you should take care not to overdo the effect.

Unless they are really coarse, the texture of fabrics is virtually imperceptible from all but the closest distance. More often than not, it is revealed by the quality of any surface pattern or decoration. It also depends on the quality of the lighting: strong, directional light will make the surface folds and creases far more apparent than flat, even lighting.

Practice exercise: Folded fabric

Most fabrics are soft in texture. Sometimes you can use the distorted lines of the pattern to show how the folds and creases in the fabric fall; at other times, particularly if the fabric is a uniform colour, they are revealed by variations in tone. Look for both these things when drawing fabric.

Materials

- Smooth drawing paper
- 2B pencil
- Soft eraser

The subject

Here, a man's handkerchief was folded and rucked up slightly at one side to create interesting creases and shapes within the fabric.

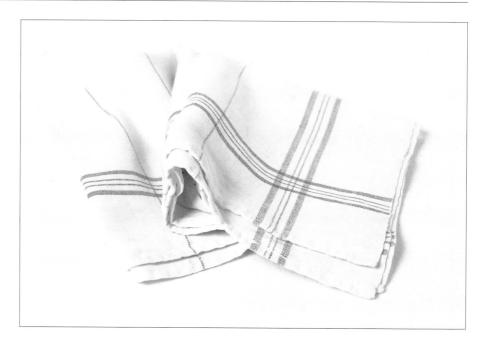

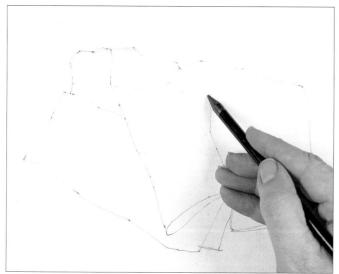

1 Establish the shape of this crumpled handkerchief using a 2B pencil. Use light, flowing lines to suggest not only the shape but also the position of any shadows.

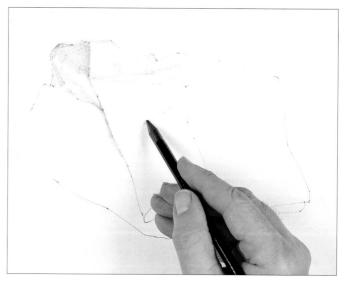

2 Begin to put in the tones, using scribbled pencil marks that follow the contours of the fabric. Use light pressure for the very light tones, holding the pencil high up the shaft.

3 Continue steadily searching out the contours and the relevant tones.

Gradually the form of the object becomes apparent.

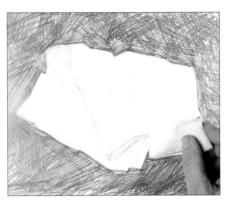

4 Give the area surrounding the handkerchief a dark tone. 'Draw' in any light creases on the fabric using a soft eraser.

5 Finally, draw the patterned lines that are woven into the fabric of the handkerchief, carefully following the shape of the contours.

Note how careful observation of the subtle differences in tone, from the white of the paper for the most brightly lit areas to a pale covering of grey elsewhere, reveals the gentle folds in the fabric. More abrupt folds are indicated by the changes in direction of the pattern woven around the edge of the handkerchief.

Practice exercise: Feathers

When you are drawing a bird, it is neither necessary nor advisable to put in every single feather – particularly if you are drawing a front view, as the chest feathers tend to be relatively small. Look instead for the blocks of feathers and think about their function: are they strong, primary feathers that are used for steering and to produce the power of flight as the wing is brought down through the air, or the softer, more pliable secondary feathers that lie above the primary feathers? Also think about the skeleton that lies underneath the feathers, as this will make it easier for you to get the shape of the body and head right.

Materials

- Smooth drawing paper
- Fine liner pen

1 Using a fine liner pen, map out the main shape and features of the bird of prey's head. Use small, jagged strokes around the edge to convey the texture of the facial and neck feathers.

 $\mathbf{2}$ Draw in the position and shape of the main feather groups – the feathers at the base of the head and on the bird's chest.

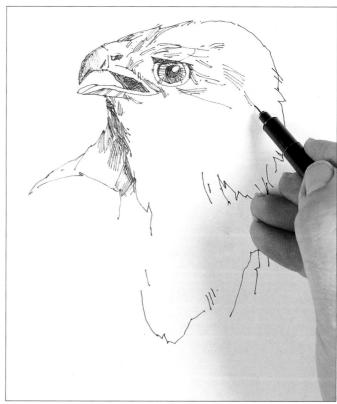

Blaborate the main feather groups, defining some feathers more clearly than others. Colour in the eye, remembering to leave the highlight untouched.

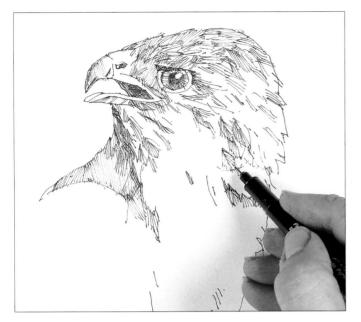

 $\mathbf{4}$ Build up the tones by increasing the density of the pen lines, carefully following the surface contours of the underlying body structure.

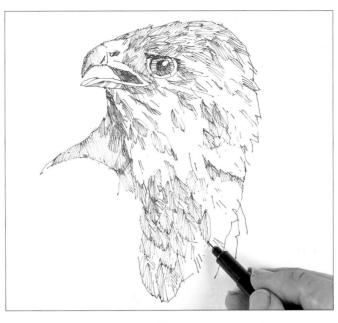

5 Finally draw the cluster of feathers that runs from the bird's neck over its chest. They help to give the subject a sense of solidity.

Using a liner pen can give a drawing a rather mechanical feel if you're not careful, and the trick is not to put in too much detail. Here, the artist has created the soft texture by drawing pen lines that follow the direction of the individual strands within the feathers.

Make sure the beak looks hard and slightly shiny.

Even though some areas are left almost blank, the viewer's eye fills in the missing details.

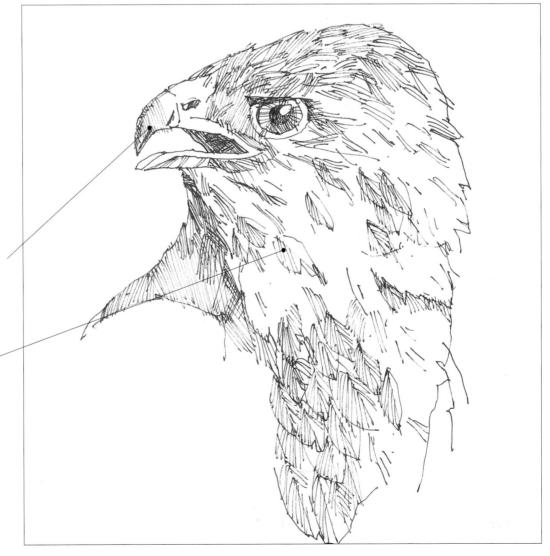

Index

applying a glaze 58

bamboo pens 15
battery-powered sharpeners 18
blending tools 19
blending with a solvent 58
blending with water-soluble
pencils 64–5
brush drawing 66–7
poppies 67–9
brushing over water-soluble ink
70
brushing over waterproof ink
70

carré sticks 21 chalks mid-toned ground 33 charcoal 9 blending 32 dots and dashes 32 mid-toned ground 33 clips 19 coloured media 10-11 coloured papers 17 coloured pencils blending 54-7 Conté sticks 11 handling 21 craft knives 18 cross-hatching 58

dark tone, creating 71 dip pens 14 drawing boards 19 drawing paper 16 drawing rough textures 88 pitted stone 90–1 weathered driftwood 88–9 drawing smooth textures 84 metal olive oil pourer 86–7 smooth leather ball 84–5 drawing soft textures 92 crumpled fabric 92–3 feathers 94–5

easels 19
equipment
blending tools 19
coloured drawing media
10–11

drawing boards 19 easels 19 erasers 18 fixative 19 monochrome media 8-9 paper 16-17 pastels 12-13 pen and ink 14-15 sharpeners 18 eraser drawing 78 still life 79-80 erasing tools 18 using 78 exercises blending coloured pencils 55-7 combining permanent and water-soluble inks 71-3 crumpled fabric 92-3 drawing a straight-sided object using negative shapes 40-1 feathers 94-5 metal olive oil pourer 86-7 pitted stone 90-1 poppies 67-9 reducing a simple still life to basic shapes 26-7 seascape in soft pastels 59-61 shading rounded objects 36 - 7shading straight-sided objects 34-5 simple landscape viewed as geometric shapes 28-9 simple line drawing 22-3 smooth leather ball 84-5 still life 79-80 still life in oil pastels 62-3 using torn and cut masks 74-7 weathered driftwood 88-9 woodland scene 81-3

fibre-tip pens 15 finger blending 58 fixatives 19 fountain pens 15

graphite pencil
contour shading 32
cross hatching 32
scribbled tone 32
still life with garlic and
shallots 164–7
water-soluble 8
graphite sticks 9
handling 20
grids 39

hard pastels 13

ink 14 combining permanent and water-soluble inks 71–3 controlled hatching 33 pen and wash 33

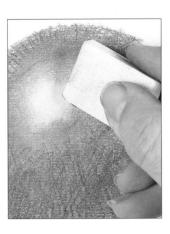

kneaded erasers 78

layering 58
line and wash 70–1
combining permanent and
water-soluble inks 71–3
line drawing 22–3
simple shapes 24–5
simple still life 26–7

marker pens 15 marks 20–1 brush drawing 66–7 masking 74–5 erasers 78 measuring systems 38–9 monochrome media 8–9

negative shapes 40–1 drawing rounded objects 42–3 nibs 14

oil pastels 13 blending 58, 62–3

paper 16-17 pastel papers 17 pastel pencils 13 pastels 12-13 pen and ink 14-15 pencil sharpeners 18 pencils grades 8 handling 20 using a pencil to measure 39 perspective, 44-53 aerial 44 circular forms 53 coastline 44 curved forms 52 distant trees 45 ellipses 53 horizontal planes 49 multi-point 48 single-point 48 sketch-plotting 49 two-point 48 vanishing 48, 49 vertical 45 Pointillist technique 58

portable table easels 19 preparing surfaces 17

quill pens 15

reed pens 15 rollerball pens 15

sgraffito 81 woodland scene 81-3 shading 32-3 rounded objects 36-7 straight-sided objects 34-5 shapes 24-5 drawing a straight-sided object using negative shapes 40-1 masking 74-7 reducing a simple still life to basic shapes 26-7 simple landscape as geometric shapes 28-9 shaping erasers 78 sharpening tools 18 sketchbooks 16 sketching pens 15 soft pastels 12 blending 58-61 spatial depth 44 see also perspective square-profile graphite sticks 9 straight lines: masking 74 supports 16-17

table easels 19 technical pens 15 textural marks 21 tone 30–1 shading 32–3 torchons 19 blending 58

water-soluble pencils 10 white papers 16

Acknowledgements

Special thanks to the following artists for stepby-step demonstrations: Diana Constance: pages 34-5, 62-3. Douglas Druce: page 30-1. Abigail Edgar: pages 22-3, 36-7, 40-1, 42-3, 59-61, 74-7, 81-3. Suzy Herbert: pages 55–7. Wendy Jelbert: pages 65, 66-9. Paul Robinson: pages 70-3. lan Sidaway: pages 20–1, 24–5, 26–7, 28–9, 32–3, 38-9, 54, 58, 64, 74, 78-80, 81 (top), 84-95. Effie Waverlin: 44-52.